IMAGES
of America

KINGSTON

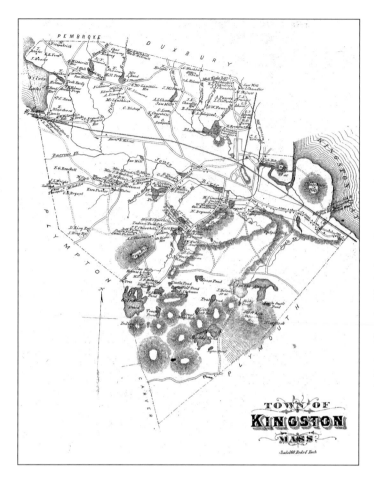

This map of Kingston from an 1879 atlas of Plymouth shows the town located in the coastal lowlands on Kingston Bay, bounded on the north by the towns of Pembroke and Duxbury, on the east by Duxbury and Kingston Bay, on the southeast by Plymouth, and on the southwest by Carver and Plympton. Kingston is characterized by sandy-to-gravelly soils with a complex topographical relief in the southern portion of the town. The Jones River bisects the town from west to east, flowing from Silver Lake, in Pembroke and Plympton in the west, to Kingston Bay, in the east.

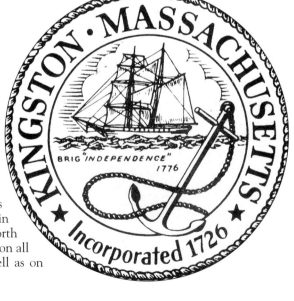

In 1950, Kingston commercial artist Helen Foster was commissioned by the town to design the first official town seal. The design illustrates the brig *Independence*, built in Kingston; her anchors were forged in a Kingston foundry along the banks of the Jones River. The brig is all tied together within a rope formed at the Cordage in North Plymouth. The town seal now appears on all official documents of the town, as well as on the official town flag.

IMAGES
of America

KINGSTON

Norman P. Tucker

ARCADIA

First printed in 2001.

Published by Arcadia Publishing,
an imprint of Tempus Publishing, Inc.
2A Cumberland Street
Charleston, SC 29401

Printed in Great Britain.

Library of Congress Catalog Card Number: 2001091707

For all general information contact Arcadia Publishing at:
Telephone 843-853-2070
Fax 843-853-0044
E-Mail sales@arcadiapublishing.com

For customer service and orders:
Toll-Free 1-888-313-2665

Visit us on the internet at http://www.arcadiapublishing.com

This book is dedicated to Emily F. Drew (1881–1959), historian and photographer. Among Emily Drew's many astonishing accomplishments was that of preserving her town's history through photographic images. She left an unsurpassed collection of more than 600 glass "lantern slides," which record the history of Kingston of her time and its inhabitants. She photographed existing images that were decaying to preserve the contents and also took her own photographs of various houses, buildings, views, events, and individuals, some of which appear in this book, thereby creating a remarkably vivid history of the town.

Kingston history was her favorite subject, and she not only recorded it visually but documented it in meticulous identifications of each photograph, narrative descriptions of her slides, articles, and papers. She gave frequent talks to the then Jones River Village Club. Drew was a prime influence in the formation of that club, now the Jones River Village Historical Society, and its acquisition of the 1674 Maj. John Bradford House. One of Emily Drew's many contributions to the town was her essay "A History of Her Industries," published in 1926 to commemorate the 200th anniversary Kingston. Emily Drew's legacy of a town's past preserved has kept the history of Kingston alive.

CONTENTS

ACKNOWLEDGMENTS

The collections in the Local History Room of the Kingston Public Library, which make this book possible, are a testament to the foresight and dedication of a vast number of individuals, past and present. To those who have documented that history, recorded it visually, and assured its preservation, there is only heartfelt gratitude. It is hoped that all those individuals will be recognized, in one form or another, somewhere in this book.

For the past few years, I have had the opportunity to learn about Kingston from many with such dedication. It is to the credit of the library's director, Sia Stewart, that the Local History Room was established and she and her trustees have strongly supported the history room as a serious research center. I am grateful to Sia for her support of this project and to archivist Andrew Pollock for suggesting that I prepare this publication. True appreciation for her assistance in choosing and identifying images goes to Janice Guidoboni, a history room researcher for many years whose knowledge of the collections and of the town is truly amazing. The former archivist, B. Joyce Miller, whose accomplishments in collection research and organization are impressive, introduced me to the history room and its collections. She is also a wonderful teacher, of great benefit to both volunteers and interns. My experience was enhanced by the frequent presence of former town historian Doris Johnson, her infinite knowledge of Kingston, and her oft-consulted *Major Bradford's Town*. I had the true pleasure of the company of a tireless history room volunteer, Ethel Shiverick, whose tenure as town librarian from 1967 to 1983 justly earned her the status of prime gatherer and preserver of Kingston records, protecting them for years in her Adams Library office. Finally, I express my gratitude to Margaret Warnsman, who recently retired as library trustee after 22 years but serves as town historian. A lifelong resident of Kingston, she is an astonishing source of information about the town and only eager to share. She is especially proud of the Local History Room and has been most generous in her support of the growth of the collections there. Many volunteers and interns, too numerous to be mentioned here, have only further vitalized the experience. To all of you and to others perhaps not named, but not forgotten, *Kingston* is your book.

INTRODUCTION

Kingston is a historic town located in the Coastal Lowlands on Kingston Bay. Established as a town in 1726, it was originally the North Precinct of Plymouth. In 1717, 41 residents of the northern part of Plymouth petitioned the general court to be set off from Plymouth as a separate township or precinct. They were allowed to become Plymouth's North Precinct on the condition that they maintain a suitable minister. By 1717, the population had grown to 48 families. At that time, the central part of the present town of Kingston belonged largely to Maj. John Bradford. He gave the precinct 14 acres of land to be used for the town wood lot, the Training Green (c. 1720), the Old Burying Ground (c. 1717), and a meetinghouse (not extant). The settlement area became known as the Jones River Village and remained, for a time, the focal point for European settlement with a primary cluster developing on Main Street between Evergreen and Summer Streets.

In 1726, the North Precinct, after having been a part of the town of Plymouth for 106 years, acquired its independence and became the town of Kingston. At the time of its incorporation, Kingston's population stood at 550 residents. Today, the original Jones River Village includes a compact, well-preserved area of 18th-, 19th-, and 20th-century residential and institutional structures that reflect the area's early dominance as a developing town center. The area encompasses the Kingston Town House, the Training Green, the First Parish Meeting House, the Old Burying Ground, Evergreen Cemetery, the Baptist Church, the Faunce School, and the Frederic C. Adams Library.

Eventually development spread to the eastern side of the Jones River and Rocky Nook, annexed from Duxbury in 1857, with the Great Bridge over the Jones River connecting the two areas. The potential for mill industry, marine-based activities and farming were important factors in the development of these two areas as Kingston's residential, commercial, and civic center. The Jones River acted as a focus for shipbuilding during the late 17th and early 18th century, with Rocky Nook providing the rigging for larger ships at its wharves. From the beginning, the three major shipyards built more than 300 vessels. Mill and iron industry challenged farming as the primary economic activity in the early 18th century. Mid- and late-18th-century settlement remained focused on the bay area with scattered nodes around industrial sites at Triphammer on Wapping Road and the mills at Furnace Brook.

The civic center lost its commercial dominance as the coming of the railroad drew business to the railroad station area at Summer Street just north of the present Evergreen Street in the 1850s. Rocky Nook began serving as a residential suburb of North Plymouth with the demand

for housing for Plymouth Cordage workers. Establishment of the Cobb and Drew tack factory also drew worker housing developments to this area, which helped settle immigrant populations in the area. In 1907, Kingston had eight manufacturers of nails and tacks, more than any other place in America. A trolley was built for the Plymouth Cordage workers in 1889 and was extended to serve the northern portion of town in 1894. Shipbuilding gradually phased out by 1874. Early-20th-century development at Rocky Nook focused on summer cottages and facilities associated with summer resorts. The western portion of Kingston underwent some post–World War II residential development.

Until the 1980s and 1990s, Kingston appeared to have escaped the intensive development experienced by other southeastern Massachusetts communities. At the end of World War II, there were fewer than 3,000 people. However, with the completion of Route 3 as a four-lane, divided highway in the 1960s, population began to grow. The return of the Old Colony Railroad in 1997 has brought even greater development. By 1980, there were more than 7,000 residents and, by 1990, more than 9,000. Today's population is over 11,000.

As Kingston celebrates its 275th anniversary with a variety of commemorations and events, we are reminded of past efforts to mark and document significant milestones in the town's history. In fact, Kingston's rich and varied history has been remarkably well documented over the years, not only visually but in print.

Goals of the 250th anniversary included the publication of Doris Johnson Melville's landmark *Major Bradford's Town: A History of Kingston 1726–1976*, the first comprehensive history of the town of Kingston. One hundred years before, there was a historical sketch of the town of Kingston done by Dr. Thomas Bradford Drew. The 200th anniversary, in 1926, saw *The Civic Progress of Kingston*, by Sarah Y. Bailey; *A History of Her Industries*, by Emily F. Drew; and *Ships of Kingston*, by Henry M. Jones. These works have long been the standard reference works for the study of the town. In support are numerous articles, memoirs, diaries, reports, and photographic images. From the early years of the Frederic C. Adams Public Library *c*. 1898, the generous giving of historically minded Kingston townspeople steadily built the photographic collections now housed in the library's Local History Room, established in 1994. The history room has as its motto, "Preserving Kingston's Past." In *Kingston*, we have attempted to share some of that past through a selection of the images that have survived.

One
SOME EARLY HOUSES

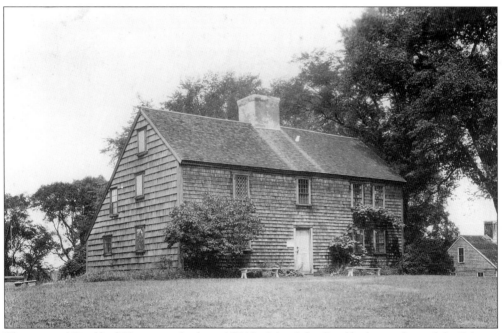

The original Bradford House was built in 1674 by Maj. John Bradford, grandson of the Pilgrim Gov. William Bradford, for his bride, Mercy Warren. The original structure was the section from the door to the left in this photograph. In this space, they raised 10 children. Around 1717, when son William married, a new foundation was dug and the east half of the present structure was added to it, creating a center-entrance saltbox. The house was in use as a two-family house when the Jones River Village Club purchased it in 1921.

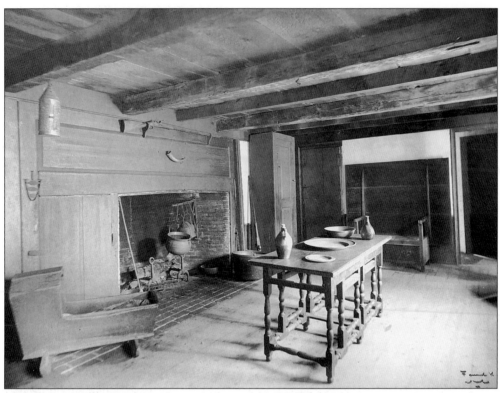

This early view shows the kitchen of the Maj. John Bradford House.

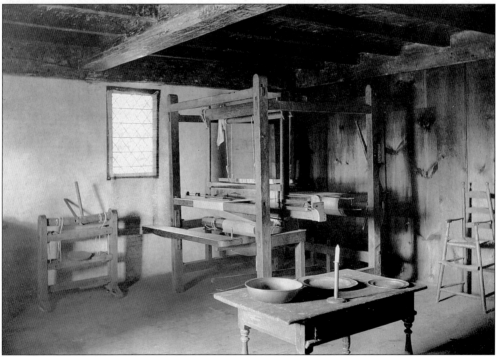

The living room at the Bradford House is shown in this undated photograph.

10

What may be the oldest surviving house in the Old Colony, the Willett house, built c. 1639, still stands. It remains a private residence, located on the north side of the Wapping Road, west of the Jones River Triphammer Bridge.

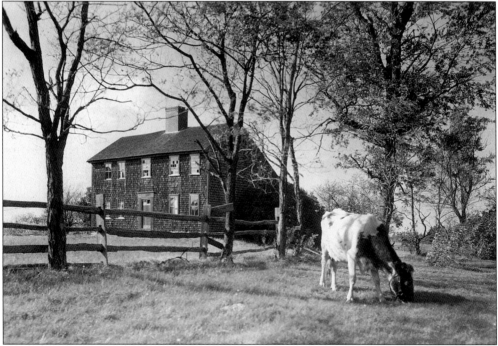

Thomas Willett conveyed the Willett house, shown here c. 1922, to William Bradford in 1653. The Bradford family owned it until April 1747, when it was transferred to William Rand, the third minister of the town. The property was sold to John Faunce in 1785.

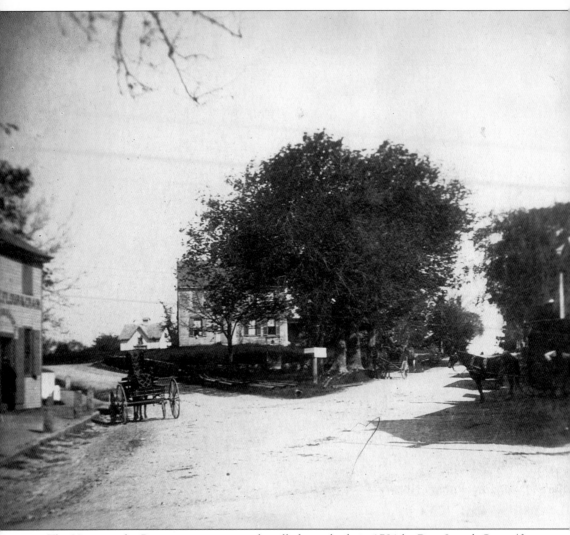

The House at the Point, as it is commonly called, was built in 1721 by Rev. Joseph Stacy (first minister of the North, or Jones River, Precinct of Plymouth) on three acres of land, given to him by Maj. John Bradford. "The Point" is formed by the intersection of Boston Road, now Summer Street, to the east, and Bridgewater Road, now Main Street, to the west. It was around this intersection, on the slight hill that rises from the Jones River, that the town center developed. This photograph clearly shows the Cushman store on the left.

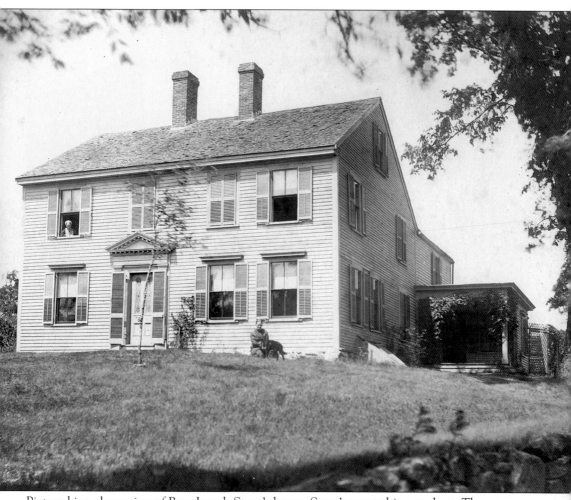

Pictured is a closer view of Rev. Joseph Stacy's house. Stacy's ownership was short. There were a number of owners in the following decades and, at the end of the 19th century, the house was co-owned by Emma Ransom and Catherine "Kitty" Russell. Russell was a local teacher and member of the school committee.

The triangular piece of land known as the Point was the site of the "old point well," which was the original water supply for the neighborhood for more than 150 years. The 90-foot well was owned jointly by Samuel Foster, Benjamin Sampson, and Rev. Joseph Stacy.

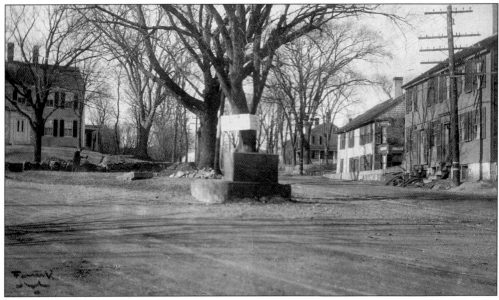

Henry R. Glover, a wealthy manufacturer of bedding and mattresses in Cambridge, gave the Henry Glover Watering Trough on the Point to the town in 1888. In 1886, town water was installed, and several residents gave to the town drinking fountains for the "benefit of horses and dogs." Two years later, the Glover watering trough was set at the Point for public use. To this day, the Point parcel is still used and owned by the town.

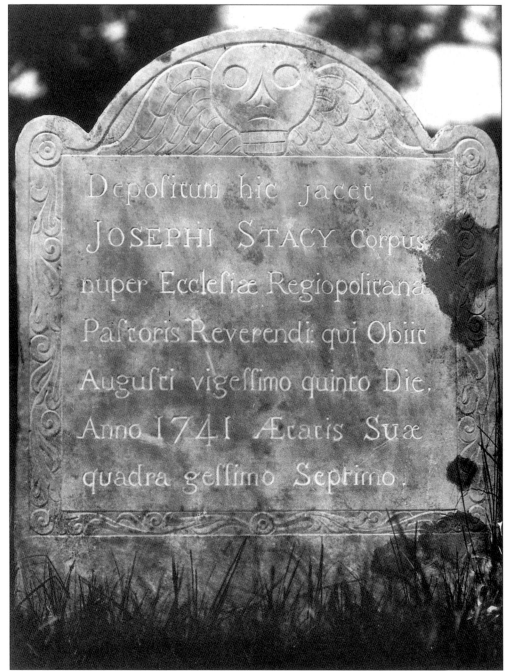

Depositum hic jacet
JOSEPHI STACY Corpus
nuper Ecclefiæ Regiopolitana
Paftoris Reverendi qui Obiit
Augufti vigeffimo quinto Die,
Anno 1741 Ætatis Suæ
quadra geffimo Septimo.

"Here lies the body of the Most Reverend Minister Joseph Stacy" is clearly stated on the gravestone of the first minister of the North Precinct in the Old Burying Ground.

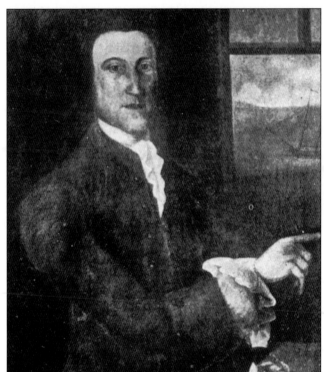

Squire William Sever, shown here in an oil portrait, was born in Kingston in 1729. The Sever family played a prominent part in business and town affairs. With his father and brother, he owned many vessels. His portrait, like those of other sea captains and ship owners, shows a vessel in the background. Squire William served as Kingston's representative to the general court starting in 1750 at the age of 21. He also served as member of the Provincial Congress of Massachusetts Bay during the Revolution and owned a storehouse and wharf on Rocky Nook on the Jones River.

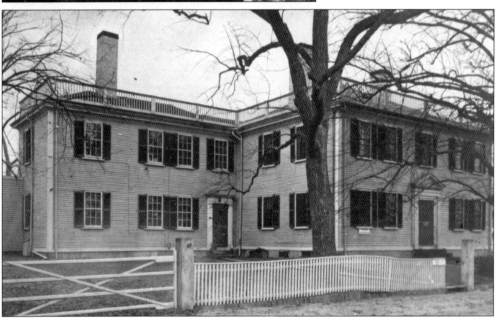

The William Sever house on Linden Street was built in 1768 within the early Jones River Village town center. The Georgian-style dwelling was constructed for Squire William Sever at time of his marriage to his cousin Sarah Warren of Plymouth. It is said that while the house was being constructed, Sarah (Warren) Sever's uncle, Gen. James Winslow, brought a shipload of exiled French neutrals to Plymouth from Nova Scotia. According to Emily Drew, some worked on the terraced gardens to the rear of the house.

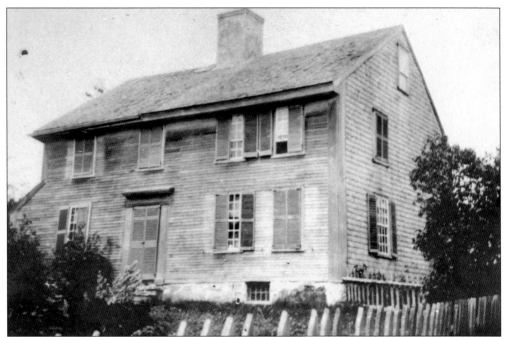

The house at 198 Main Street, known historically as the Benjamin and Crocker Sampson house, was built *c.* 1700 by Benjamin Sampson on land that he had purchased from his father-in-law, Jacob Cooke, who owned a large farm between the Jones River and the Bridgewater Road, now Main Street. Sampson lived in the house and operated it as an inn in the early 1700s. Taverns and inns were common in the Point area in the 17th and 18th centuries.

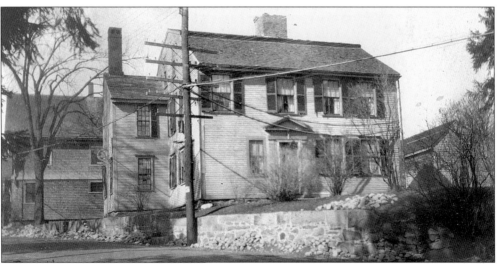

Charles Little was one of the original petitioners who founded the town of Kingston in 1726. Records indicate that in 1714 Little built the existing house on Boston Road, now 191 Main Street, on a parcel of land purchased from Maj. John Bradford. Little served on town committees and was voted the first assessor of the town in 1718. When Little died in 1728, his widow, Sarah, with no means of income, opened a tavern in the residence, which became known as the Widow Little's tavern, reputed to be the first tavern in town.

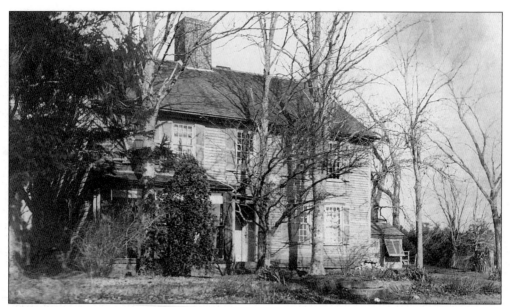

Deacon Wrestling Brewster's house on Brewster Road was built in the Georgian Federal style early in the 1690s, according to family records. Deacon Brewster was the great-grandson of Elder William Brewster (1566–1643), the only university-educated Pilgrim. When the first Kingston town election took place in 1726, Deacon Wrestling was one of 12 Kingstonians elected to office. He was also one of a three-member committee chosen by the town meeting in 1738 to view land for classroom use. He, his brother John, and three others started a gristmill in 1746 on the north side of Stony Brook. The Brewster family occupied the house until 1968.

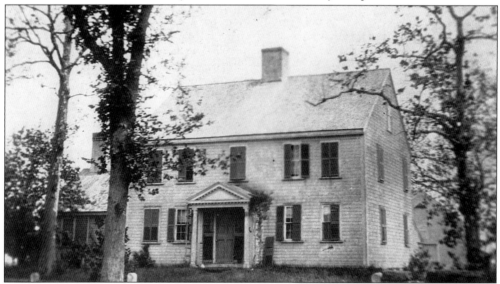

The Parson Zephaniah Willis house at 15 Summer Street was constructed c. 1740 and later served as the home of Parson Willis, which he occupied until his death in 1847. He was the fourth minister of the First Congregational Church, where he served for 50 years. He also served as town clerk and was known as a botanist. In 1784, he married a daughter of Maj. Gen. John Thomas. Willis was one of Kingston's most prominent citizens. He was highly thought of and left many valuable records, notes, and historical sketches.

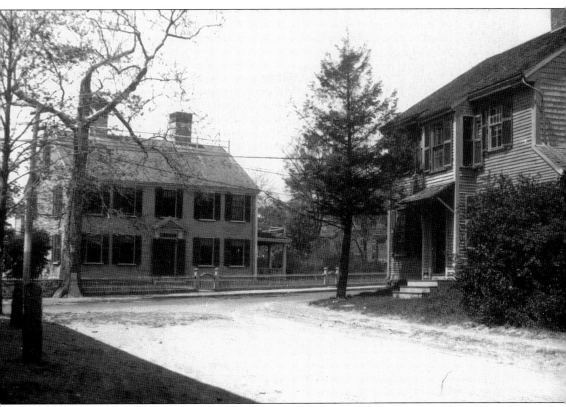

David Beal, a prominent ship and property owner and merchant who came from Hingham to Kingston, built this Federal-style house at 196 Main Street at the Point c. 1785 and added a store wing in 1794. The wing that housed the general store was in operation until 1902 when, according to Melville, "it was removed to allow rounding the corner onto the Bridgewater Road, now Main Street." Today, 196 Main Street appears much as it did when built in 1784. This is not true of the house on the opposite corner of Summer and Linden Streets visible at the right of the photograph. Kingston's "horse-and-buggy" doctor, Arthur B. Holmes, owned this two-story house until he sold it in August 1939 to the telephone company.

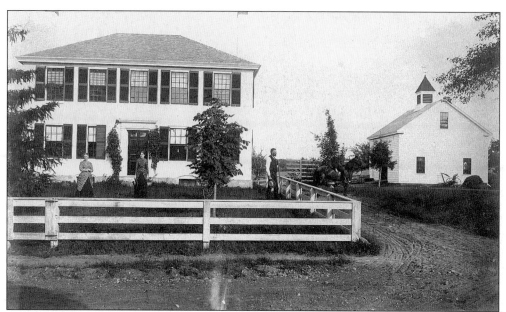

Robert Cook Jr., a mason, built the Walter Faunce house on Wapping Road in the Federal style in 1805. The house was owned by Walter H. Faunce, one of Kingston's most prominent and devoted citizens. Pictured in this remarkable image are Walter Faunce and his family c. 1883–1885, at which time he was Kingston's superintendent of schools. The Faunce family owned the house for most of the 19th century.

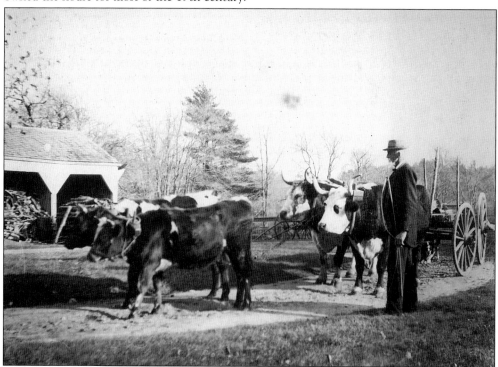

In addition to his numerous public activities, Walter Faunce was a successful farmer and was noted for his interest in livestock. He is shown here with a double yoke of oxen.

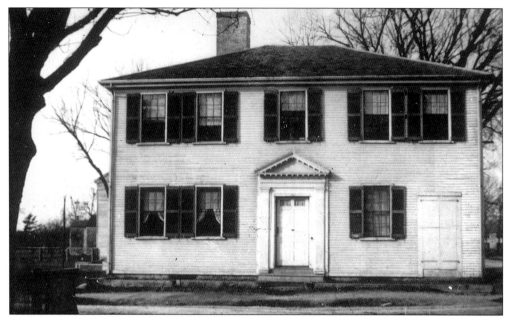

Known as the Lemuel Holmes house, the residence at 232 Main Street was built by Holmes c. 1797 to accommodate both his family and business. The lower part at the far right was the entrance to the grocery store. Subsequent owners also operated stores in the space. This was the residence of Joseph Holmes, legendary Kingston shipbuilder, who resided in the house from 1805 until his death in April 1863 at the age of 90.

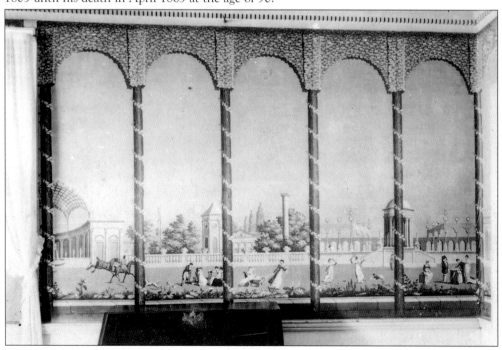

Pictured here is the famous and rare French wallpaper, which graced the parlor of the Holmes house; it was one of only five sets of this paper known to have been imported. According to Melville, it was "reproduced in the 1920s by the Nancy McLellan, Inc. firm in New York City."

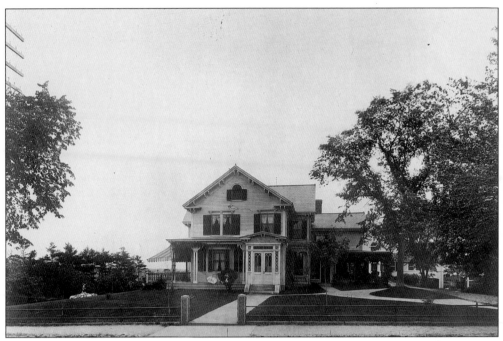

This house, known as the George T. Adams house, was the home of Frederic C. Adams, one of the most influential men in Kingston during the 19th century and one of its greatest benefactors. According to a sign on the house, 31 Summer was constructed in 1880. The house was the home of George T. Adams and his wife, Lydia Bradford Adams.

Lydia T. Adams was born in Kingston in 1821, the daughter of Thomas and Lydia (Cook) Bradford. She married George T. Adams, and their son Horatio was born in 1845. According to an obituary notice published in the April 4, 1908 issue of *Old Colony Memorial*, she was a direct descendent of Governor Bradford, the Mayflower Pilgrim.

Two
SCHOOLS, CHURCHES, AND PUBLIC BUILDINGS

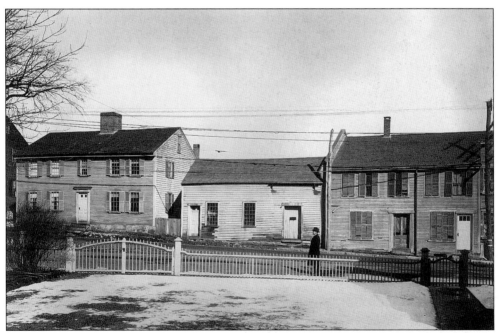

This group of buildings at Summer and Linden Streets included the first school in the North Precinct. The school is at the center between the house of Lazarus Drew on the left and the store of James Sever on the right. The school operated here for nearly a century, had a commercial use thereafter, and was torn down in 1922 when Summer Street was widened. The Lazarus Drew house was later owned by Rev. Samuel Glover, Baptist minister whose son Henry R. Glover gave the memorial drinking fountain trough, which stands opposite at the Point.

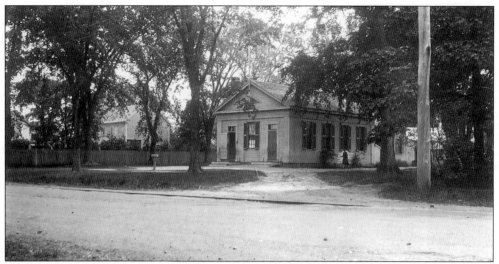

The Faunce School, originally known as the Centre Primary School, was constructed in 1844. In 1888, a small rear room was added to the building. In 1924, the two-room school was renamed in honor of Walter H. Faunce, a former teacher, superintendent of schools, and town selectman. The building was abandoned as a school in 1926 and, over the years, has undergone many renovations and multiple uses. In 1972, a complete restoration of the building was voted as part of the 250th anniversary effort. This was completed and the restored school was dedicated in November 1974. The school is now used for meetings for public and private organizations.

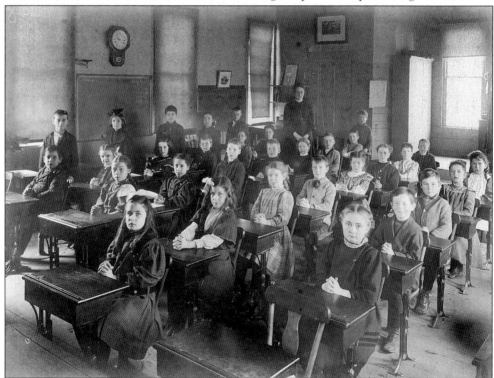

Up until the 1900s, one or two teachers taught the first through fourth grades. In this c. 1880 photograph, the pupils are at attention for their picture in Sarah B. Faunce's class.

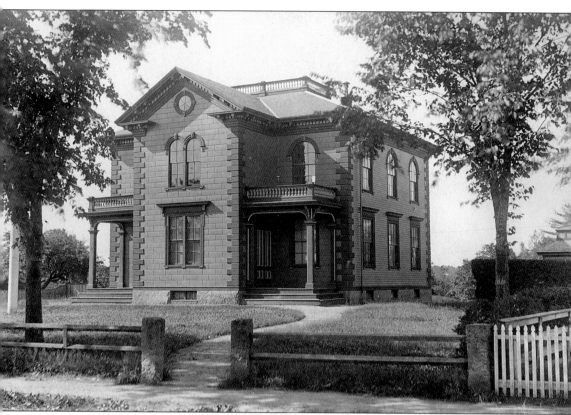

Much photographed and, therefore, a familiar site is the Kingston High School. It is one of the most instantly recognizable buildings in Kingston, although it no longer exists except in the memory of many and in photographs such as this one. Town meeting in 1866 voted to spend $10,000 to build the town's first high school, one classroom plus offices and closets on each of two floors. The new building was dedicated on May 10, 1867.

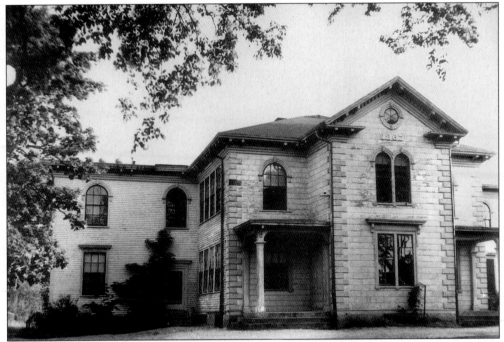

The school had subsequent additions and was in service for 95 years, not even a century from the day of its dedication. This photograph shows the school in a state of abandon.

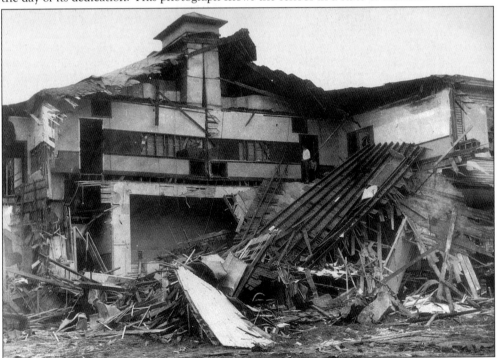

This photograph leaves no question of the school building's fate; it was razed in October 1962. Although the facility was not adequate to meet the needs of the town and was in need of updating, it had become a photographic landmark.

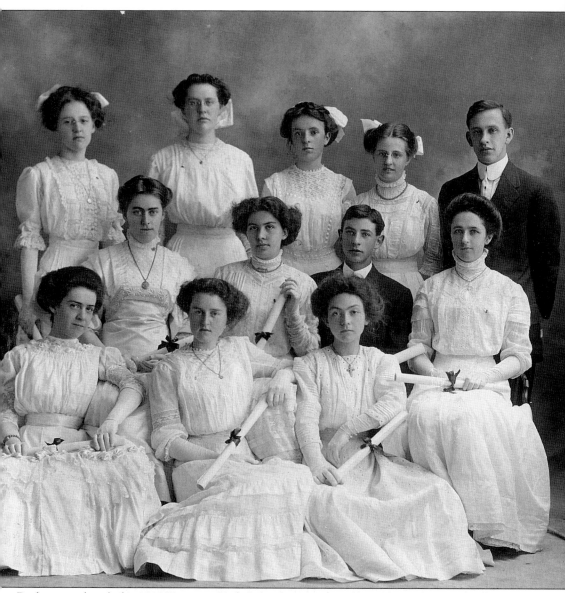

Diplomas in hand, the 1910 Kingston High School graduating class is shown here. From left to right are the following: (front row) unidentified, Gretchen Holmes Dries, and unidentified; (middle row) Frances Cole Chandler, unidentified, George Randall, and Irene Chandler Pratt; (back row) Natalie Monks, Marion Reinhardt, unidentified, Mildred Farrington, and Isaac Hathaway.

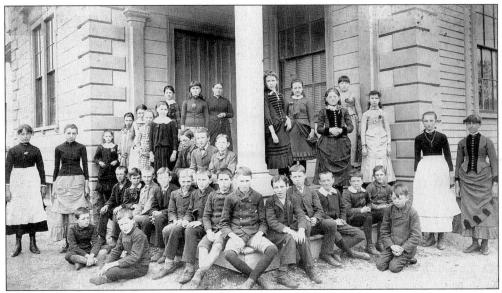

Unidentified students pose in this *c.* 1890s photograph, taken on the steps of the Kingston High School.

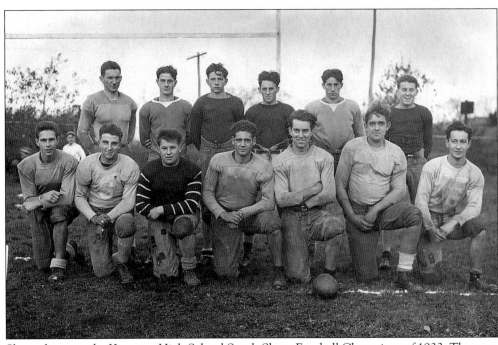

Shown here are the Kingston High School South Shore Football Champions of 1933. They are, from left to right, as follows: (front row) Bob Bailey, Raoul Corazzari, George Candini, Clyde Melli, Eddie Cadwell, Stephen Reed, and Bob Davis; (back row) Malcolm Peterson, Alfred Breineau, Harold Alberghini, Chester Morrison, Amelio Ruffini, and Russell Prouty.

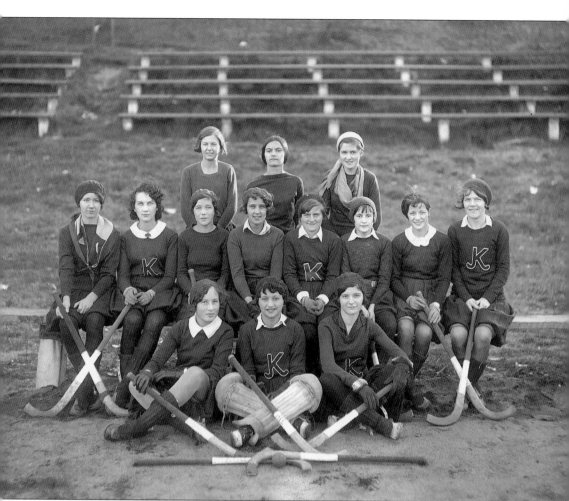

Team sweaters are on proud display in this photograph of the Kingston High School girls' hockey team of 1930. There are many familiar names. The team members are, from left to right, as follows: (front row) Jeannette Stegmare (Dickson), Olga Alberghini Spath, and Harriet Havey; (middle row) Julia Avery (Watson), Irene Toabe, Ruth Pratt (Loring), Lucy Glass, Norma Drew Neal, and Evelyn Siebenschu; (back row) Alice Bradford (Gretch), Aurelia Pimental, and unidentified.

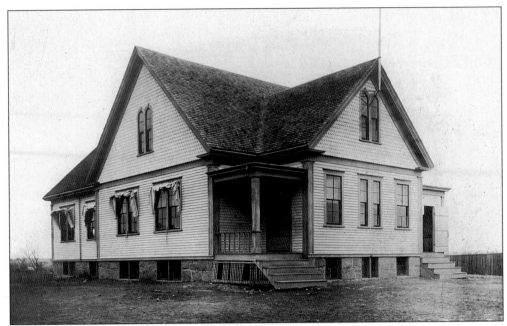

The Howland's Lane School was built in 1899 to satisfy the increasing demand for school space during the late 19th century. The area around the school was being developed with housing to serve the mills in the area and was populated by a significant number of immigrants. The Howland's Lane School became overcrowded and was rendered unfit for school purposes. The school was closed in 1950, and the building now serves as the home of the Hillside Club.

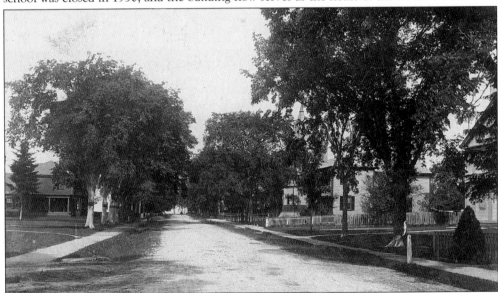

In 1842, Wylie R. Ellis established the Ellis School. An inscription on this photograph says that "until 1880 he educated not only local boys and boys from our own states [at the school], but boys from Cuba, Jamaica, Puerto, France and Spain." Ellis and his family lived in a house opposite the Baptist Church on Main Street. Both the house, at left, and the church, the third building on the right, are visible in this unusual photograph of this section of Main Street. The school stood in the yard behind the house and was torn down in the late 1800s.

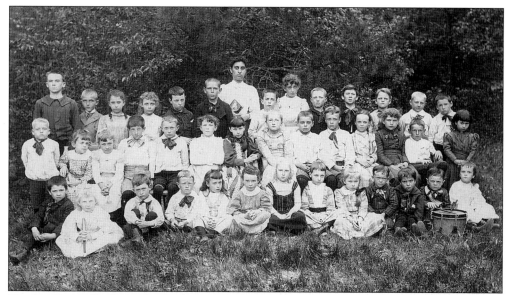

Teacher Bessie Faulkner was in charge of this gathering of pupils of the Ellis School for Boys. Faulkner was the granddaughter of Wylie Ellis. She is seen here in the center of the back row. The group includes Helen Farrington, the daughter of Kingston's longtime jeweler. Apparently, the school also admitted girls.

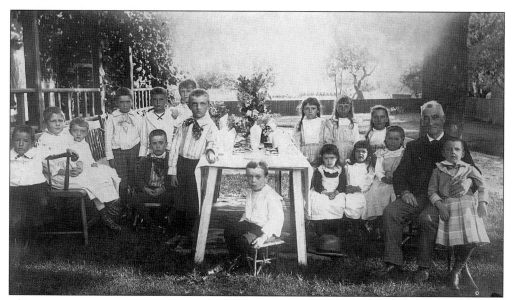

This picture of another gathering at the Ellis School shows, at the far right, Wylie Ellis, the founder of the school. The boy in his arms is Johnnie Faulkner, his grandson. The small boy at the end of the table is Robert Cushman, son of George E. Cushman, the grocer.

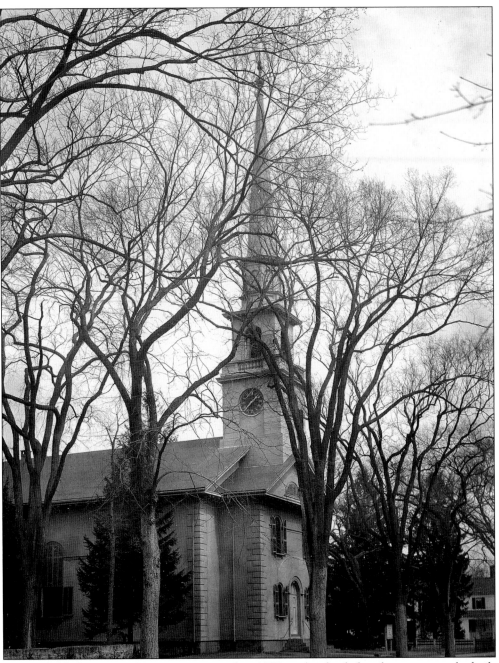

The First Parish Meeting House, constructed in 1851, is the third church structure to be built at 221 Main Street. Maj. John Bradford gave the land for Kingston's first church in 1717, and the first meetinghouse was built in 1718. In 1798, the first church was taken down and replaced by a new two-steeple church. In the spring of 1851, the 1798 church was taken down and, during the summer, a new church was constructed.

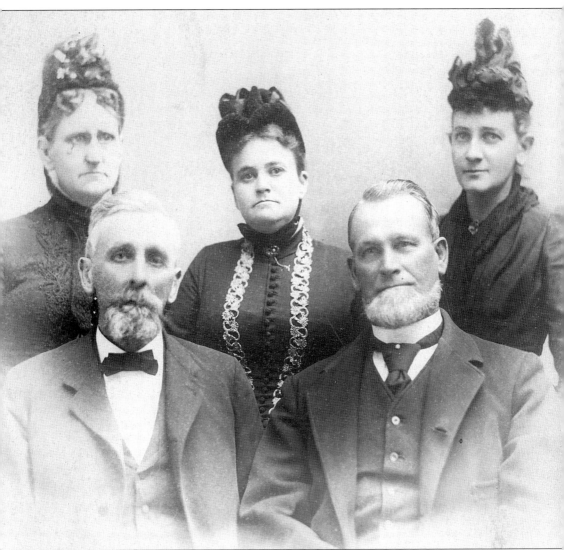

Pictured is the famous Unitarian Choir, which served for many years. From left to right are the following: (front row) Walter Faunce, tenor, and George McLauthlen, bass; (back row) Juliette (Drew) Washburn, alto; Hannah (McLauthlen) Paddleford, organist; and Ina Hall, soprano.

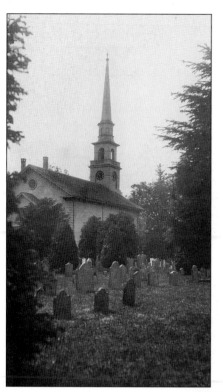

The rear of the First Parish Meeting House is shown here along with a section of the Old Burying Ground. Maj. John Bradford set aside two acres of land to be used for the Training Green, the Old Burying Ground, and a meetinghouse. The Old Burying Ground was used for burials as early as 1717, when Charles, the infant son of Charles and Sarah Little, was buried there. Other early burials include Maj. John Bradford himself and his wife.

The Mayflower Congregational Church at 209 Main Street was completed in 1829 and is considered a well-preserved example of an early Gothic Revival church with Greek Revival details. According to Emily Drew, this is the oldest church building still standing in the town of Kingston. Rev. Joseph Peckham (son of artist and leader in the Congregational Church Robert Peckham) was the preacher at the church almost continuously between 1842 and 1881.

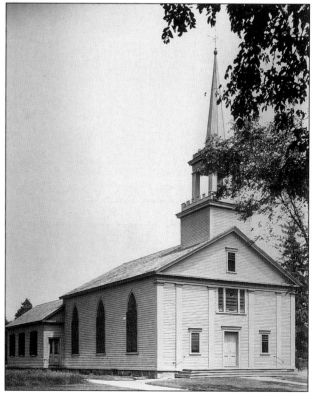

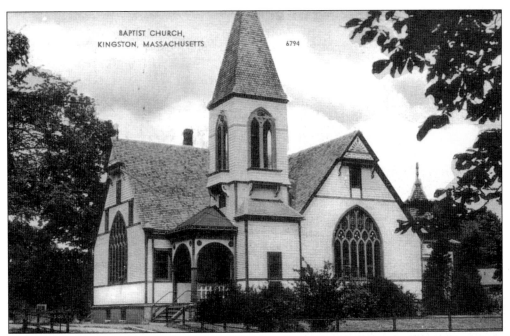

The Kingston Baptist Church, located at 213 Main Street, was built by the Baptist Society in 1886, a society created at the time of the first of two ruptures with the original Congregational Church in Kingston. The history of the society and the construction of a suitable house of worship has a lengthy and intricate history. The present church is clearly a Gothic Revival building.

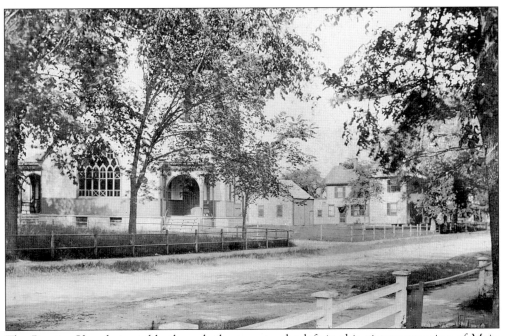

The Baptist Church is visible through the trees to the left in this picturesque view of Main Street, not far from the town green.

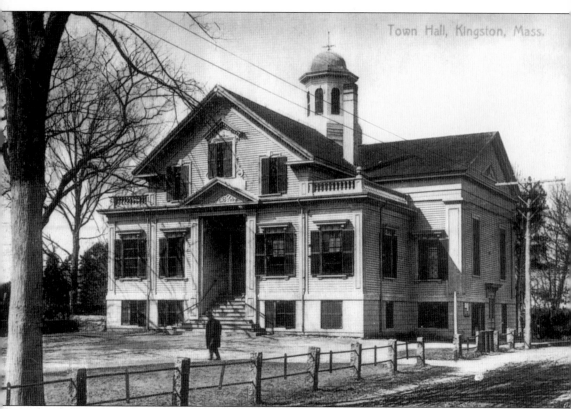

The Kingston Town House was built in 1841 on the two-acre parcel of land which Bradford set aside for the Training Green, the Old Burying Ground and a meetinghouse. The Town House, as it appears today, is not what one would have seen originally. By the 1870s, the town was considering construction of a new town hall, and a committee was formed for this purpose. The committee was also asked to present a proposal for the enlargement and remodeling of the old building. It was decided to retain the Town House and do extensive alterations. In 1877, it was enlarged, remodeled, raised, and turned around so that it now faced the town green. Today, the Town House is considered a well-preserved example of the Greek Revival style and one of the most architecturally distinguished buildings in the town of Kingston.

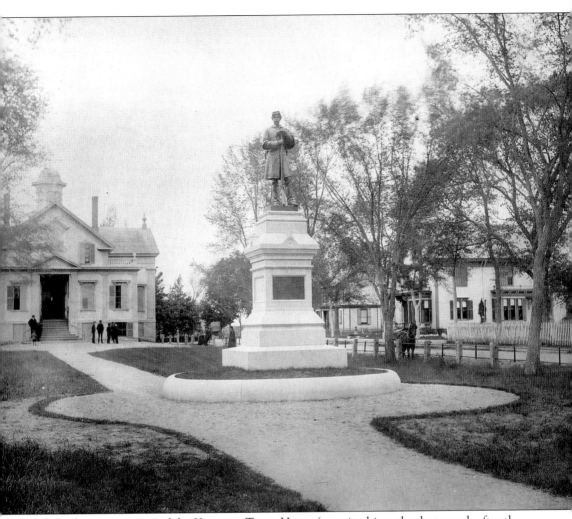

Prior to the construction of the Kingston Town House (seen in this early photograph after the addition of the Soldier's Monument), various groups in town held their meetings in church buildings. After it was built, the Town House became a community center; in fact, the surrounding area quickly became the town's civic center, forming the core of what would be considered today as the historic civic district. Shown to the right in this view is today's Green Street which, in 1759, was laid out as a shortcut from the Boston Road, now Summer Street, to the Bridgewater Road, now Main Street, and named Meeting House Lane.

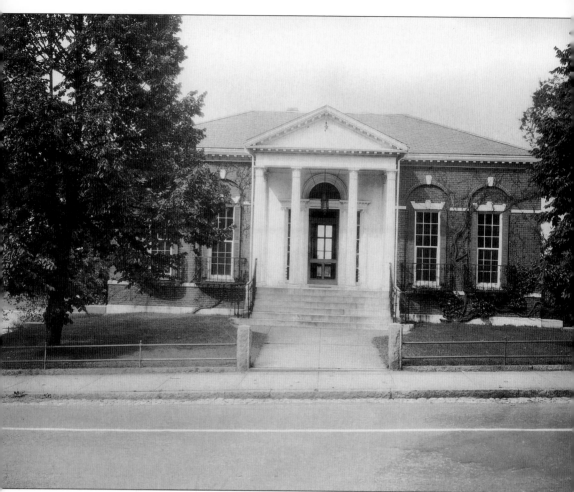

The Frederic C. Adams Library, one of Kingston's most familiar sites, was, until its abandonment in 1994, the town library. The Colonial Revival structure was designed in 1897 by Joseph Everett Chandler, a renowned Boston architect, and continues to maintain its importance as an architectural and cultural landmark in the historical center of town. The library was vacated in favor of a newer and larger facility, the former AT & T building, across the street on Green Street. The Adams Library building has recently been declared eligible for listing in the State Register of Historic Places and is currently undergoing architectural study for rehabilitation as a town heritage center.

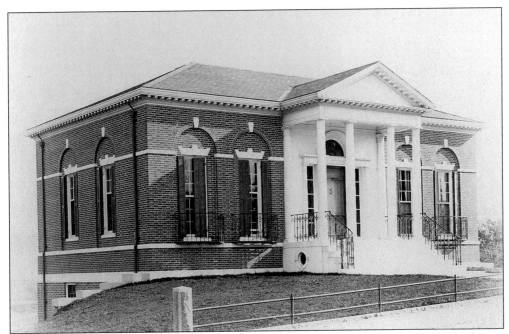

This pristine view is most likely as the building appeared when completed. In 1964, the library underwent extensive renovation, and space needs were met by the construction of a children's wing at the rear of the building, a space now used for various town group meetings.

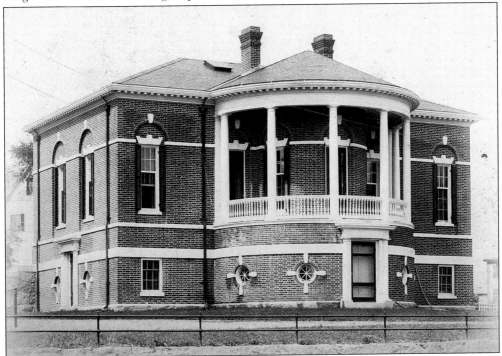

This view of the Adams Library no longer exists. It shows the rear of the building as originally designed and built, with the large round projecting bay enclosed with a Doric-column porch. This rear porch has been largely obscured by the 1964 addition at the ground level.

Dedicatory
Exercises

Of the

FREDERIC C. ADAMS
PUBLIC LIBRARY
BUILDING

KINGSTON, MASS.

Town Hall,
Thursday, August 4, 1898,
2.30 P. M.

Shown here is the official program for the dedication of the Frederic C. Adams Public Library building on August 4, 1898. At this official ceremony, hymns were sung to the tune of "America" and "Auld Lang Syne," addresses were given by various town leaders, and a special poem was composed for the occasion.

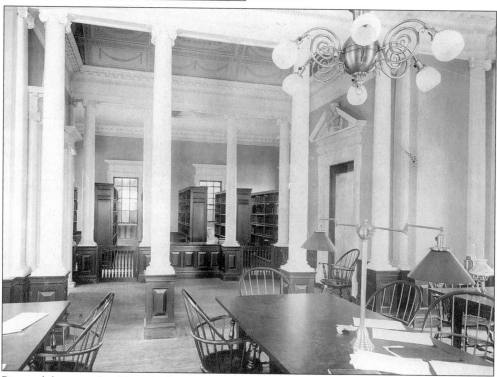

Pictured here is the library's former main reading room with its circulation desk in the foreground and its book stacks beyond, a space that is more or less as you would see it today as it undergoes re-use study.

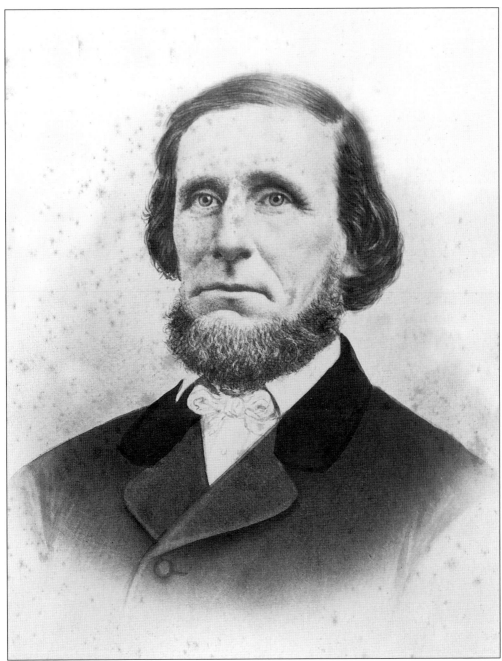

Frederic C. Adams was born in 1821 and ran the family stockyard and slaughterhouse with his brother George, on Summer Street not far from where the library bearing his name now stands. Frederic C. Adams married his older brother Horatio's widow, Eveline Holmes Adams, in 1847. Adams represented the town in the Massachusetts General Court in 1861, and was commissioned as an enrolling officer at the time of the drafting during the Civil War. Adams died in 1874 and left a bequest, which following death of his heirs was designated for building a hall for a public library and for "the purchase of Books, Statuary or Pictures as the School Committee may deem best."

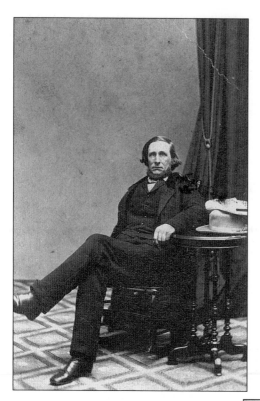

The need for a public library in Kingston had been identified as early as 1871, when the Kingston Library Association was established to provide library services to the town. Frederic C. Adams was the second president of this organization. As an active and concerned citizen, he was outspoken on all matters of importance to the town.

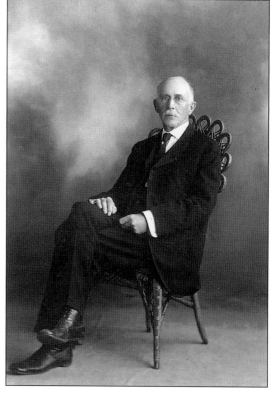

Horatio Adams was one of the key players in the fulfillment of Frederic C. Adams's wish to establish a library in the town of Kingston. He and his mother, Lydia Adams, the widow of Frederic's brother George T. Adams, gave the land on which the library was built.

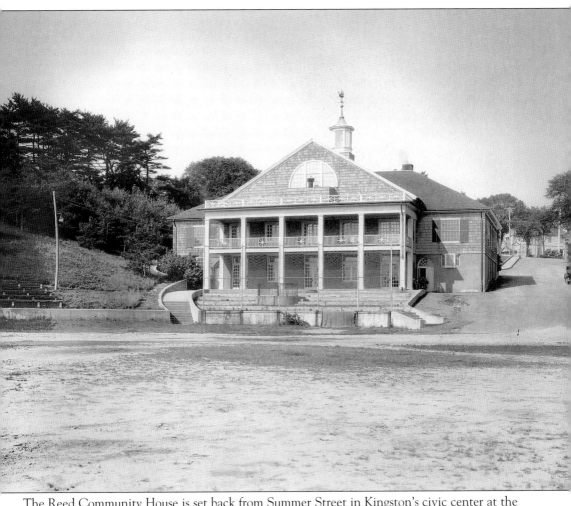

The Reed Community House is set back from Summer Street in Kingston's civic center at the bottom of a slope behind the Frederic C. Adams Library. On December 20, 1926, as part of the town's bicentennial events, Edgar Reed of Worcester, a Kingston native, formally presented the town with the completed Reed Community House. Edgar Reed was a descendant of Jesse Reed, a successful Kingston inventor and tack maker. S. Lincoln Rhodes designed the building.

Also in 1926, Capt. Fred L. Bailey presented to the town the newly completed playground at the rear of the Reed Community House. The Kingston Playground was built by townspeople as a community project and was under way in 1923.

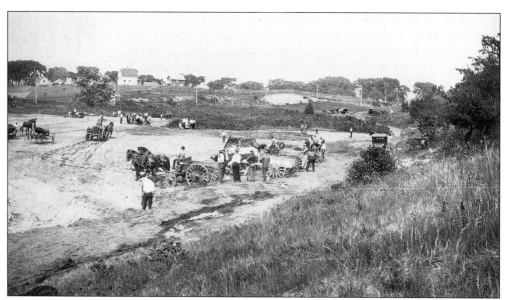

Although the Community House and the playground were not finished for the official bicentennial day, many events took place on the unfinished field.

Three

STREET VIEWS, MONUMENTS, AND LANDSCAPES

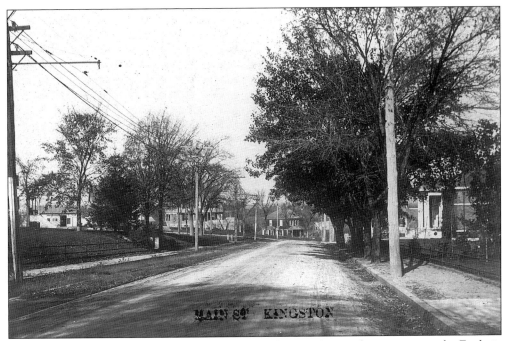

In this view of Main Street near the intersection of Green Street, the entrance to the Frederic C. Adams Library is visible at the right.

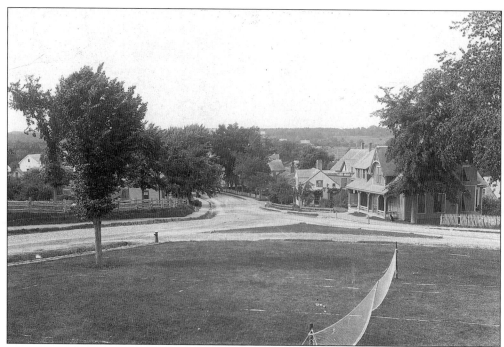

The lawn of the Kingston Inn at the intersection of Summer and Green Streets is the point of view here, looking toward downtown Kingston.

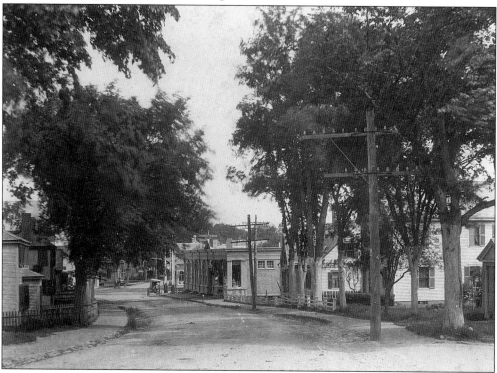

This is a similar view to the one above, closer to the town center and the railroad tracks, showing the post office building on the right.

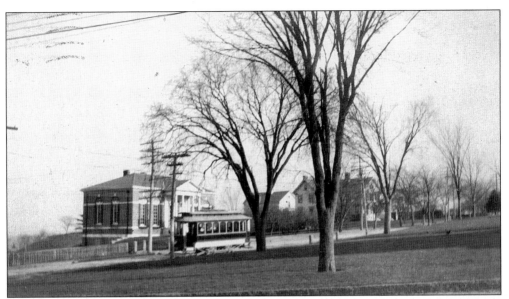

This postcard view shows the trolley making a stop in front of the Frederic C. Adams Library on Summer Street.

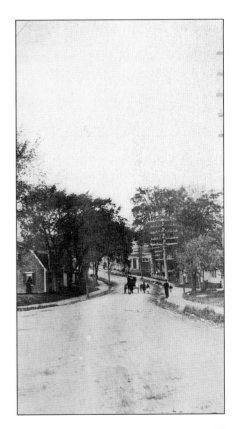

A horse and buggy is making its way up Patuxet Hill toward the Green Street intersection in this view of Summer Street, looking toward downtown.

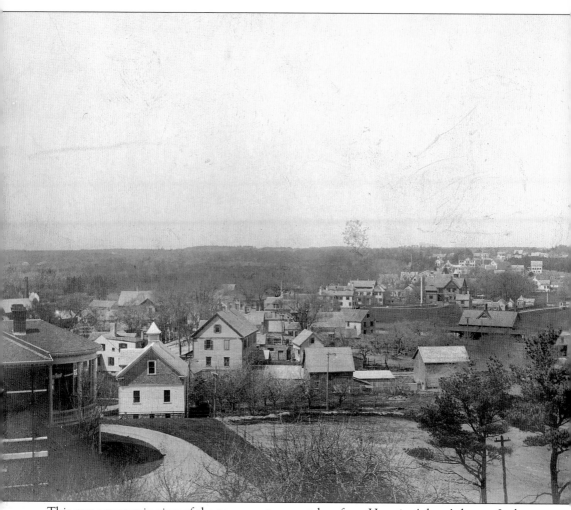

This rare panoramic view of the town center was taken from Horatio Adams's house. It shows the rear of the Frederic C. Adams Library long before the addition of the wing and before the Reed Community House was built to the rear of the library.

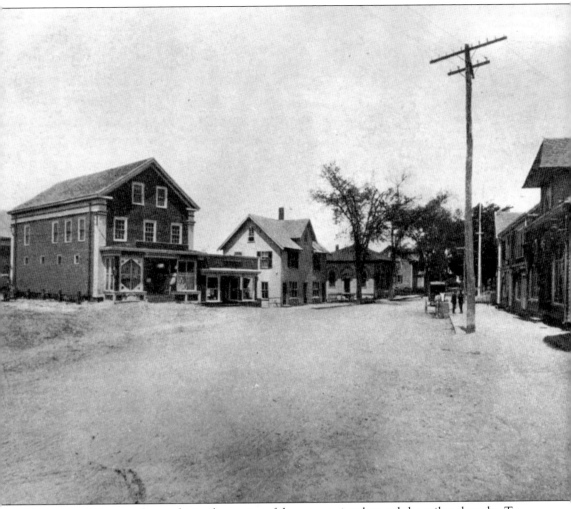

This view of Summer Street shows the center of downtown, just beyond the railroad tracks. To the left is the general store building, formerly occupied by Burges and Bailey, as well as numerous other proprietors over the years. It is still in commercial use. The second building beyond the store, approximately where the Kingston Post Office is now located, is the original railroad station. It was moved to this location from a site to the left of the store and was first used as a Chinese laundry.

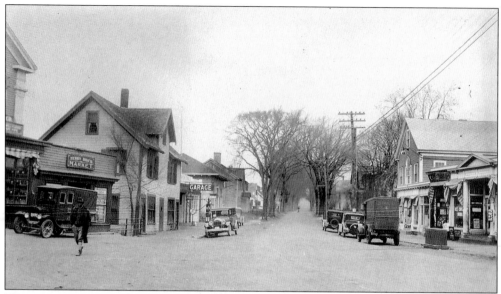

This view is unique in that it pictures, in addition to the familiar Adams Block to the right and the Keith Store on the left, a busy downtown area and a gathering of the automobiles of the day.

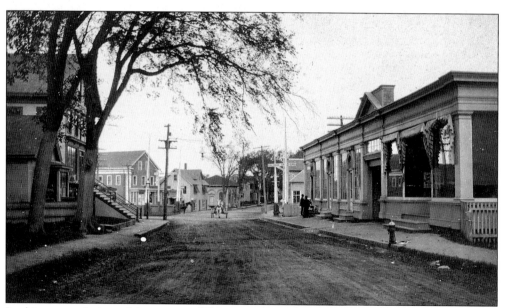

In this postcard view of the center of Kingston, the railroad crossing is visible, the post office building in what was also known as the Adams Block is seen at the right, the old railroad station is in the center distance, and the Myrick Block is at the left.

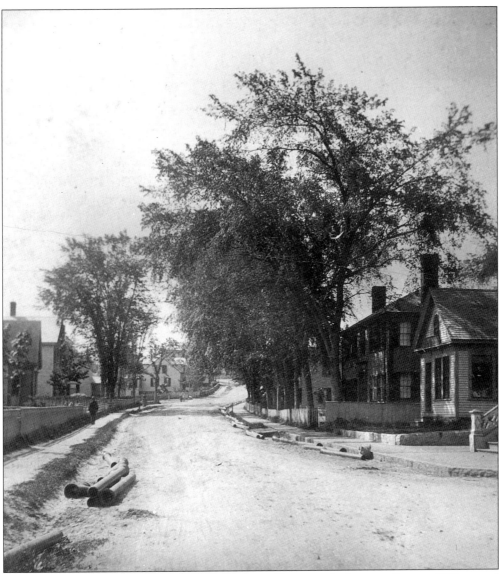

In this view, taken from the center of downtown Kingston, looking up Patuxet Hill toward Green Street, one sees evidence of the laying of the water mains in August 1886. The second building on the right is the Cook-Drew house, one of only a few brick-ended Federal-style houses in Kingston. It has changed use from a residence to commercial property but retains its architectural integrity.

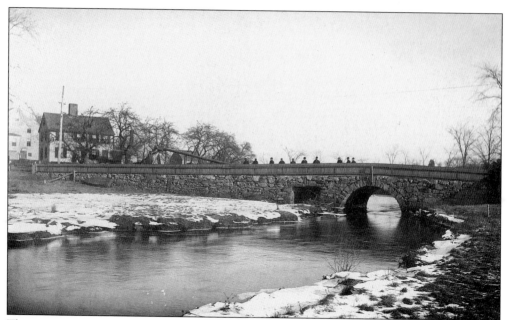

This *c.* 1880 photograph shows the Great Bridge, carrying the Boston Road (now Main Street) across the Jones River. Earlier versions of the bridge had served to connect the original Jones River Village with a secondary node along Main Street on the eastern side of the river and Rocky Nook vicinity. Kingston's Great Bridge is an immediately recognizable historic site.

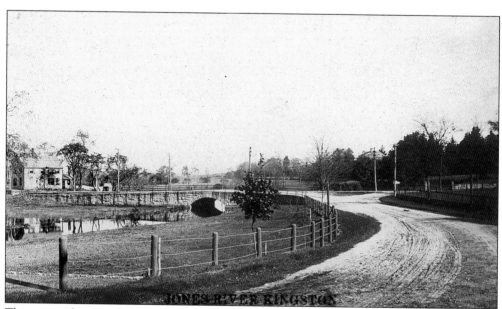

This postcard image of the Jones River offers another view of the Great Bridge as seen from an unpaved Brook Street.

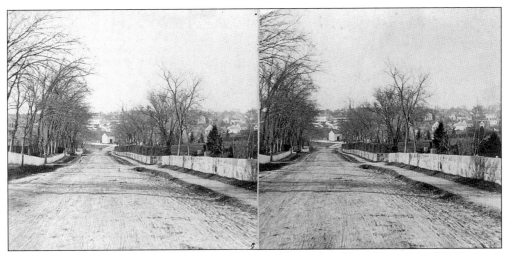

This fine example of a stereoscopic view, from the firm of M. Chandler of Marshfield, shows this classic view of Thomas Hill. The view looks north on Main Street from near the present-day Route 3 interchange. According to Emily Drew, who used this view often in her talks, the houses on Main Street and Landing Road, and the cow barn on the Colonel Sever lot, show up distinctly in the distance.

MAIN ST KINGSTON

One would not recognize this spot today, at the intersection of Main and Prospect Streets. The current Charley Horse Restaurant is at the immediate left. The photograph was taken after 1900, with the Leander Cole property in view on the right and the Ruth B. Delano property visible on the left.

This image of Crescent and Main Streets could not be duplicated today, although the houses shown at the center and to the far right are still standing.

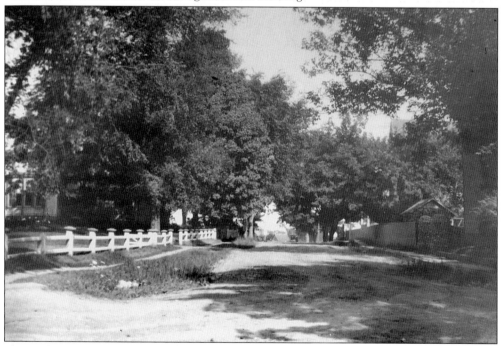

Shown here is Maple Street in downtown Kingston. The view was taken c. 1900 from just opposite where the post office is now located. The house on the left, shown through the trees, is still there and in use as a private residence.

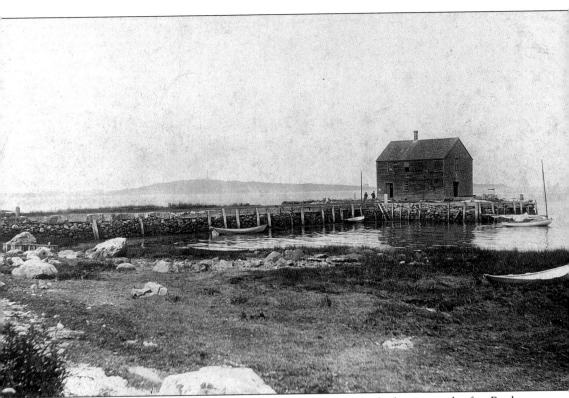

In 1802 and 1803, Benjamin Delano and Capt. Peter Winsor built the stone wharf at Rocky Nook, which still stands today. The Delano wharf, painted and photographed by hundreds of artists, is said to be similar to only two other wharves on the Atlantic coastline. The warehouse at the end of the wharf has undergone significant renovation, although the general form of the building has not been greatly altered.

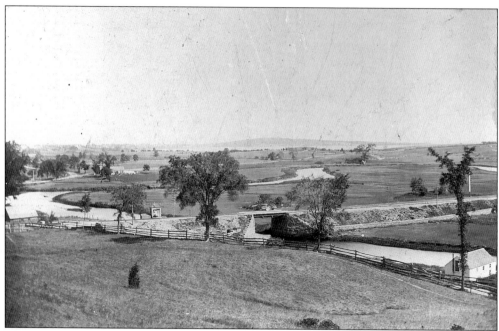

This *c.* 1890 photograph of Abram's Hill gives a superb view, looking toward Duxbury and the Miles Standish Monument. Abram's Hill is located above the Kingston Playground, behind the Adams Library and house. Note the railroad trestle over the Jones River and Landing Road in the foreground.

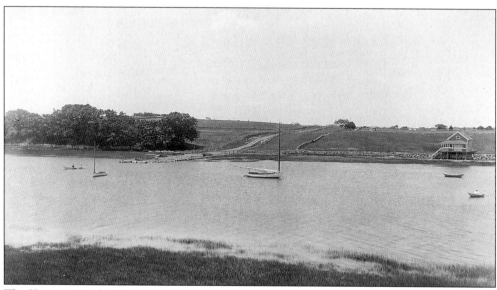

The Kingston Yacht Club is shown on the right in this photograph taken at the mouth of the Jones River.

Four

TOWN LEADERS,
HISTORIANS, AND
PERSONALITIES

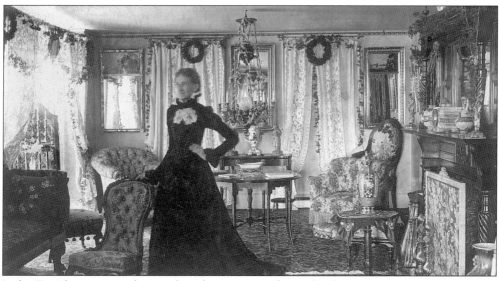

Lydia T. Adams appears here in her classic pose and was clearly a town personality. Lydia T., as she is called by some, was a schoolteacher, made two trips abroad, and took much pleasure in collecting antique mirrors which, in numbers and value, probably exceeded any similar collection in Massachusetts. They are seen here in her parlor. Mrs. Adams gave the chandelier and the bracket lamps to the First Parish Church, where she sang in the choir for many years. With her son Horatio, she presented to the town of Kingston the land on which the Frederic C. Adams Library was built.

Walter H. Faunce was born in Kingston on November 16, 1832, and died in June 1930, the son of Charles C. and Amelia (Washburn) Faunce. Active in civic affairs, not only in Kingston but also elsewhere in the state, he served two terms as representative to the legislature, the first time in 1880, and again in 1924 when he was in his 92nd year. For over 50 years, he was a member of the Kingston Board of Selectmen, most of which time he served as chairman. He was a justice of the peace for 70 years and, as a young adult, had been a schoolteacher. He also served on the Republican State Committee, was an active member of the First Parish Church of Kingston, and a member of both the Marshfield Agricultural and Horticultural Society and the Plymouth Agricultural Society, reflecting his avocation as a farmer and his interest in livestock.

Nathan Brooks, shown in a studio visiting card, was for many years town clerk and served for 21 years as treasurer of the town. He was a Duxbury boy but, upon marrying a Kingstonian, came to Kingston to live.

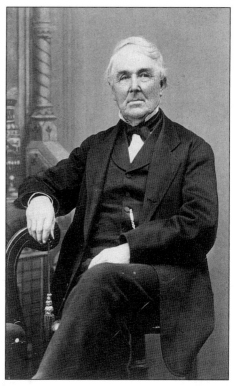

Ichabod Washburn was born in Kingston in 1798, one of twins, to Capt. Ichabod and Sylvia (Bradford) Washburn. Captain Washburn was a sea captain who contracted yellow fever as he rescued a ship in distress near the Portland, Maine harbor. He returned quickly to Kingston but died, and his widow was left to care for a small daughter and the twins, Ichabod and Charles. She saved her inheritance for her children and supported the family weaving and doing home chores in which the children assisted. At 10 years of age, Ichabod was sent to Duxbury to assist a family and later apprenticed as a blacksmith. This gave him the foundation for the great works he did later in life when living in Worcester. Upon his death, he established a fund that bears his name for the benefit of aged and "indigent" women in Kingston.

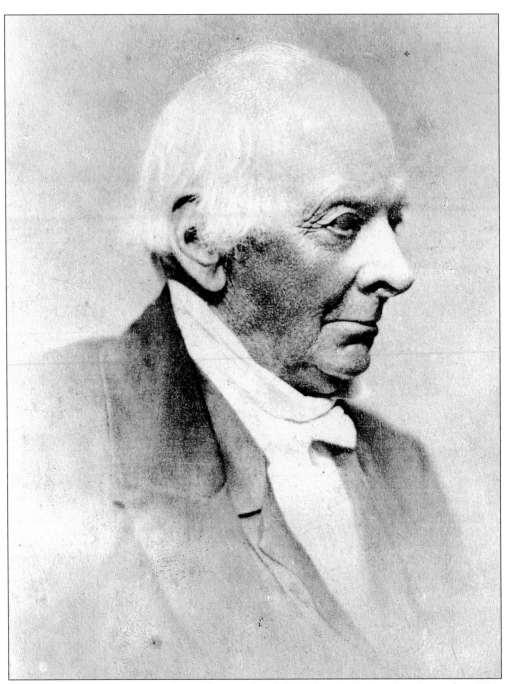

Joseph Holmes, the son of Joseph, was born on his father's farm in Kingston in December 1772. Studious and religious, he entered the College of Rhode Island, now Brown University, and upon graduation became a minister. He grew to dislike the ministry, gave it up, and leased a shipyard on the Taunton River near Bridgewater. He moved to Kingston Landing in 1806 and continued building vessels there until his death in 1863. He lived in a house on the corner of Main and Elm Streets near the town green. There he operated a store and conducted all his business and shipping transactions.

As Henry Jones writes, "Edward Holmes, the third son of Joseph Holmes, was born in Kingston in 1806. He was the last of the old-time shipbuilders of Kingston. Inheriting the landing from his father in 1863, he continued the business of building and owning of vessels until a few months before he died in 1888."

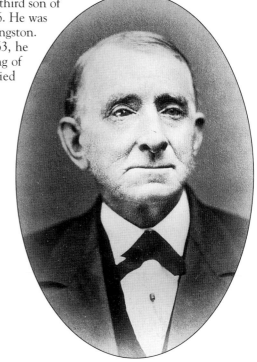

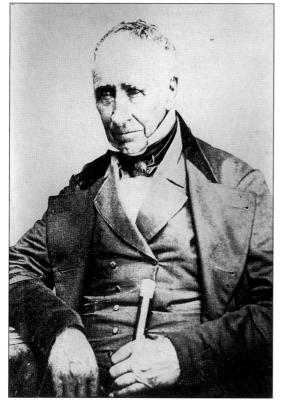

Benjamin Delano was born in Kingston and lived there until his death in 1868. He owned the sloop *Two Sisters* along with Peter Winsor, his brother-in-law, with whom he built the famous Delano Wharf. From the time his son Joshua was old enough to become his partner, he seldom owned a vessel alone. Whenever a vessel was mentioned, it was always considered as belonging to both. In addition to being a trader, a builder, and owner of schooners, Benjamin Delano was a farmer; he led a long and busy life.

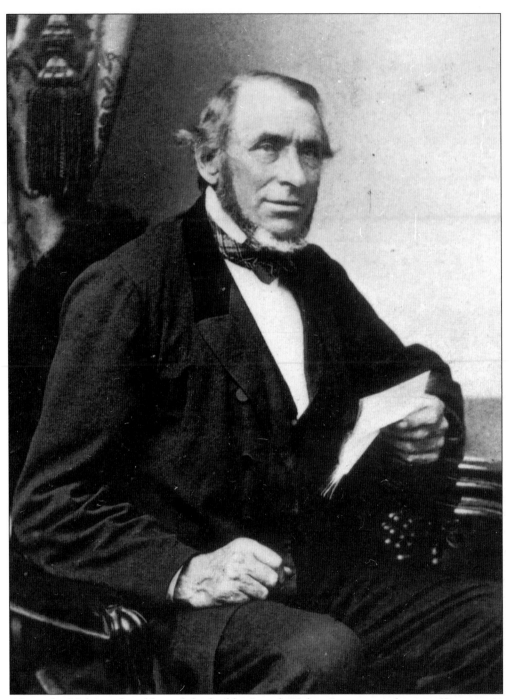

Alexander Holmes, the oldest of shipbuilder Joseph Holmes's sons, was born in Kingston in 1803. According to Jones, he never went to sea but assisted in his father's business, including ownership in vessels. In 1839, having leased the upper shipyard at the landing of John Drew, he began building vessels for himself. Upon becoming president of the Old Colony Railroad Company, he soon gave up all of his interests in shipping. He was president of the railroad company for over 12 years.

For more than 50 years, Lysander Bartlett Jr. and his father were engaged in shipbuilding on the Jones River in Kingston. According to Henry Jones, their names appear in the lists of Kingston vessels as builders but never as owners to any great extent. Their interest seemed to cease once a vessel left their yard. Some 39 vessels are listed as having been built by father and son, including ships, barks, brigs, schooners, and sloops.

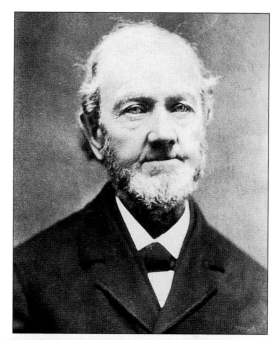

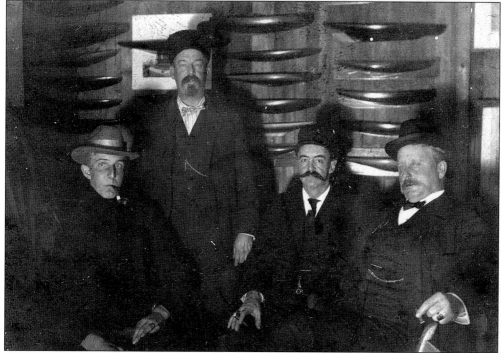

Pictured here is a gathering of a few members of the Rotary Club, shown with half-hull models on display. From left to right are Russell Adams, John Dawes (standing), Henry M. Jones, and ? Watson. Henry Jones wrote *Ships of Kingston* in connection with the celebration of the 200th anniversary of the town of Kingston. This work, as is pointed out in Doris Johnson Melville's *Major Bradford's Town*, "contains a wealth of information about shipbuilding in Kingston . . . and will probably remain the best reference book on Kingston shipbuilding."

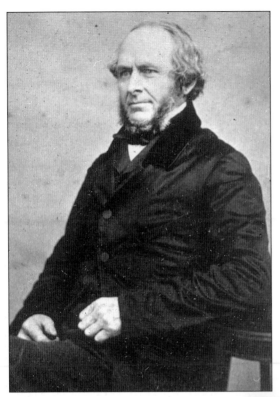

Cornelius Bartlett (1811–1880) is thought of by some as Kingston's first true historian. From January 1833, at the age of 21, he kept a diary. In later years, he edited his diaries, copied what he felt was of permanent interest, and destroyed the rest. For more than 40 years, he worked in the shipyards and as a carpenter in many Kingston houses. Throughout this time, he continued his diaries, examined town records, and consulted people about the early houses of the town. This resulted in *Houses, Occupants, etc. in Kingston, Massachusetts (Between the Forge Bridge and the Great Bridge): 1876–1879.*

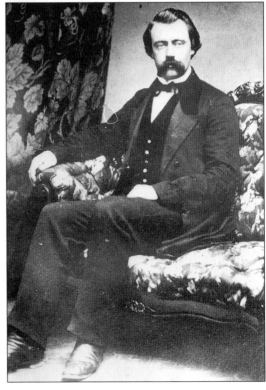

Thomas Bradford Drew (1834–1898) is best remembered for his interest in local history and genealogy. He is said to have contributed to the antiquarian publications of his era. In 1887, he was elected the librarian at Pilgrim Hall in Plymouth and served in that capacity for 11 years. Thomas Bradford Drew was a proponent of abolition and was friends with the famous abolitionist William Lloyd Garrison. A collection of numerous notebooks and manuscripts about Kingston history and genealogy that survive include his historical sketch of Kingston, which appeared for the 150th anniversary of the town.

Sarah Y. (DeNormandie) Bailey was another Kingstonian with a keen interest in Kingston history. She assisted in efforts to organize the Jones River Village Club. With a friend, she established the "Kingston Sweets," which employed women to work outside the home. Sweets were sold and later a tea room was added. Young women and girls were educated in all phases of the business. She authored *Civic Progress of Kingston*, which was published along with Emily Drew's *A History of Her Industries* to mark the Kingston 200th anniversary in 1926. She died at 67 in 1932, a lifelong Kingston resident and enthusiast.

Helen Holmes was born in Kingston, graduated from Smith College in 1887, and subsequently pursued graduate studies at Radcliffe College and the Massachusetts Agricultural College, where she was one of the first women to attend classes. She enjoyed traveling, art, music, gardening, and civic affairs and had an affinity for linguistics; she was apparently fluent in many languages. In Kingston, she served as superintendent of schools and was involved with the Maison Internationale in Geneva, Switzerland. Among numerous other activities, she was the first president of the Jones River Village Club.

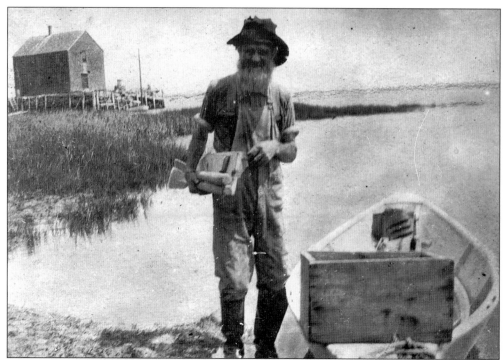

Shown here, with Delano's Wharf in the background, is Charlie Delano, a town character of some repute in the 1920s. According to E. Drew, "he was a fisherman and clam-digger, and he took orders and sold his wares throughout the town." He was much more quick-witted than most folks would give him credit for and was quite a perceptive entrepreneur. It is obvious that he did not mind being photographed.

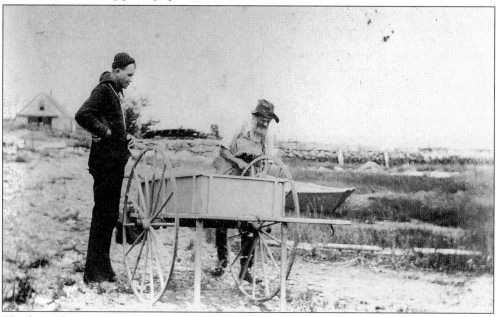

Charlie Delano is seen here with his trademark wagon and Joshua Delano. There were apparently many and successive Joshuas in the Delano family.

According to E. Drew, Martha Drew Bradford lived her later years in the westerly half of the of Stacy house at the Point. In her parlor, Bradford kept a yarn shop, where she sold all sorts of yarn, needles, and the like for fancy work for the women of the town. She died at the Point at the age of 69 and was remembered fondly as someone of great integrity with charm, wit, and intelligence.

Poet Benja (Benjamin) Mitchell of Kingston was born in 1828 and died of consumption at 37—Kingston's own tragic romantic figure. He was known as "Cousin Benja," or "Benje." During the last 10 years of his life, he was a contributor to various secular journals published in New England. He lived with his parents on a little farm in northwest Kingston, on what is now called Brookdale Avenue. He loved to roam the woods and fields. He lived in the age when Spiritualism was attracting attention in this country. Many local names of places and persons appear in Cousin Benje's poems. His sister, Julia, gathered and preserved most of his writings and, after his death, a selection of those was published in Plymouth.

George Churchill was a Civil War veteran who lived in the Indian Pond neighborhood and used to drive the horse-drawn "school team" taking the Indian Pond children to school in the center of town. It is said that he went around to the schools on Memorial Day and would tell the children what a great country he had fought for.

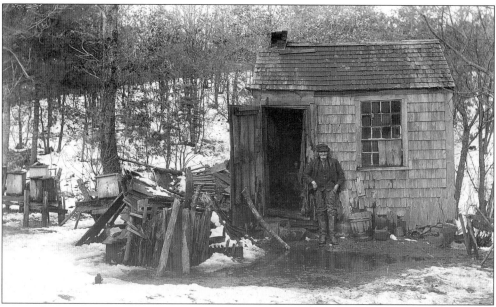

Dan Fuller, "the Hermit," was another Kingston legend in his own time and was another who did not object to being photographed. He was called the Hermit, but as Melville writes, his solitary life in his home in the woods between Ring Road and Elm Street must have agreed with him. It is said that he long outlived the famed orator and politician Daniel Webster, who often rescheduled his business in the Plymouth courthouse and spent many hours hunting with Fuller.

Five

ORGANIZATIONS, EVENTS, AND CELEBRATIONS

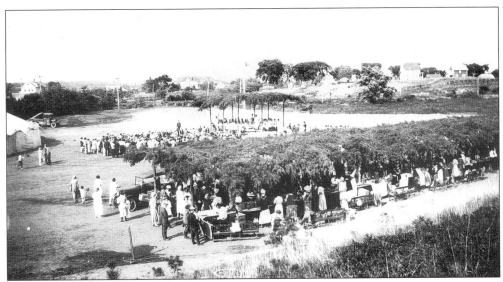

In this 1924 photograph, festivities are in full swing at the second town fair, an annual event, held on the Kingston Playground.

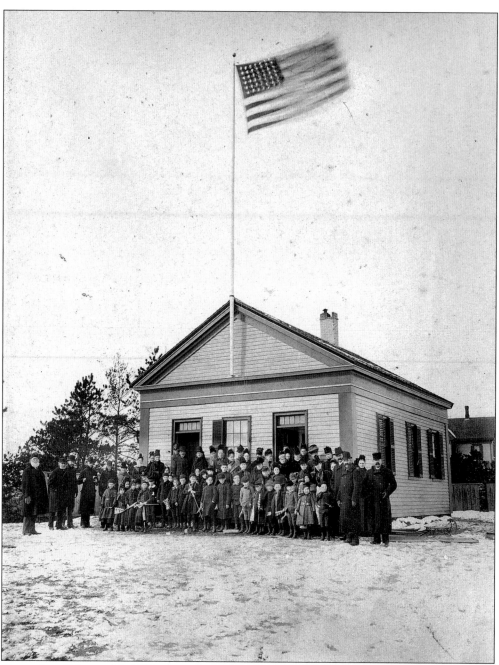

Pictured on February 22, 1890, is a gathering for the flag dedication at the Stony Brook School, on Summer Street. The Stony Brook School was built in 1844 but went the way of two other one-room schools built the same year and was abandoned in 1926. A 1901 school committee report stated that the Stony Brook School lacked the basic amenities that any village school should have. The school was converted to a residence c. 1950 and still serves that purpose.

Among those gathered for the flag dedication at the Stony Brook School on February 22, 1890, are Kingston jeweler John Farrington, the Misses Burgess, Jennie Maglathlin, and Mrs. George T. (Lydia) Adams.

Included among the pupils in this image of the flag dedication at the Stony Brook School is Kingston's own historian and photographer Emily Drew, seen first in the front on the left.

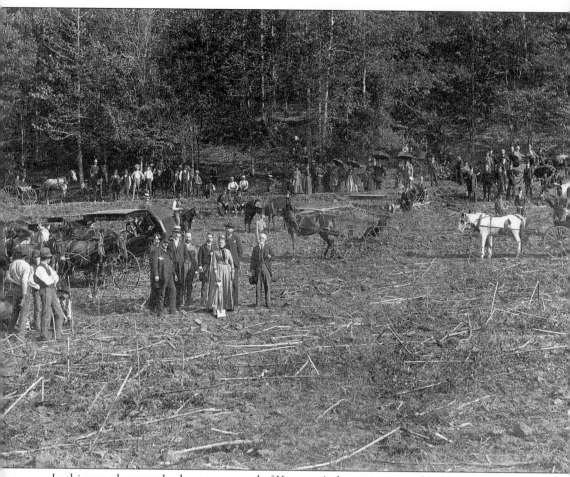

In this rare photograph, there are several of Kingston's dignitaries assembled for what is thought to be the dedication or groundbreaking for an addition to the Evergreen Cemetery. The central figure with the white beard, having removed his top hat, is Kingston's devoted citizen Walter Faunce. Eveline Adams is standing at the front the group, holding the spade. A further identifying note identifies Lydia T. Adams, seated in the surrey, shielding her eyes from the sun.

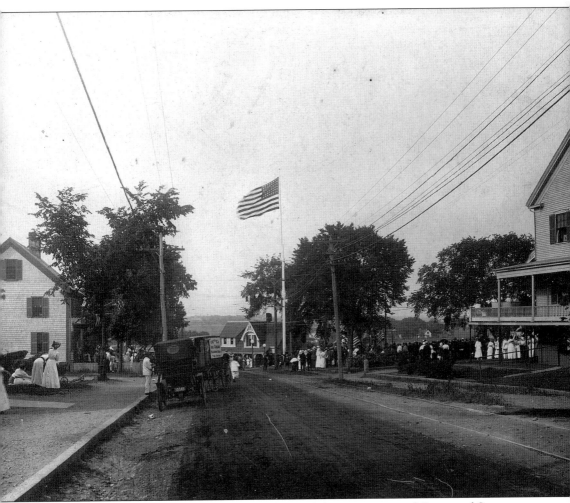

This c. 1915 view of Flag Day in Kingston looks toward the intersection of Green and Summer Streets. Kingston Inn is shown at the right on the site of the present-day Kingston Public Library in the renovated AT & T building. Note the "Currier's Ice Cream" sign on the wagon.

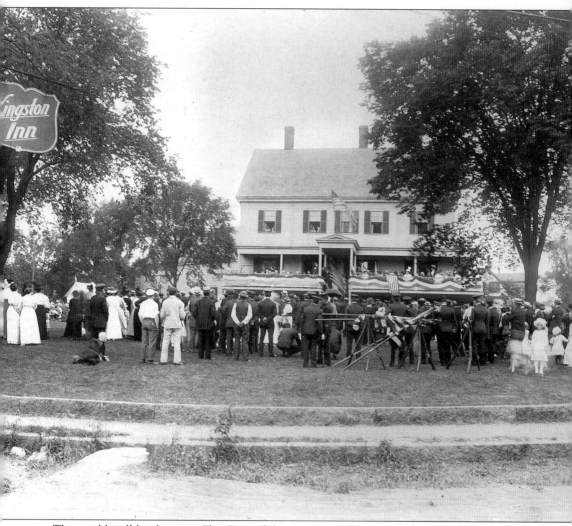

This could well be the same Flag Day celebration, now photographed in front of the Kingston Inn from the Summer Street side of the establishment. The Kingston Inn was originally called the Patuxet House when it was built in 1854. The inn operated under several names over the years and was a center of considerable activity and reputation.

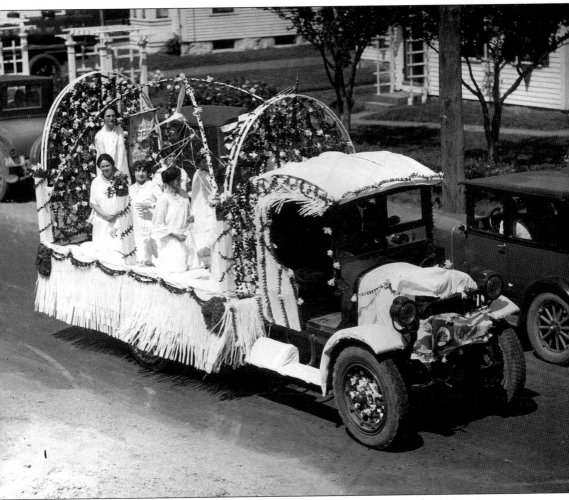

The 200th anniversary of the town in 1926 was a major celebration, culminating in many efforts and events. A grand parade was the order of the day. The Eveline Rebekah Lodge float was one entry in the parade. The participants on this float are, from left to right, as follows: (front row, kneeling) Agnes Rogerson, Barbara Haskell Burgess, Eunice Pratt Cushman, and Emily Breach; (back row, standing) Irene Pratt.

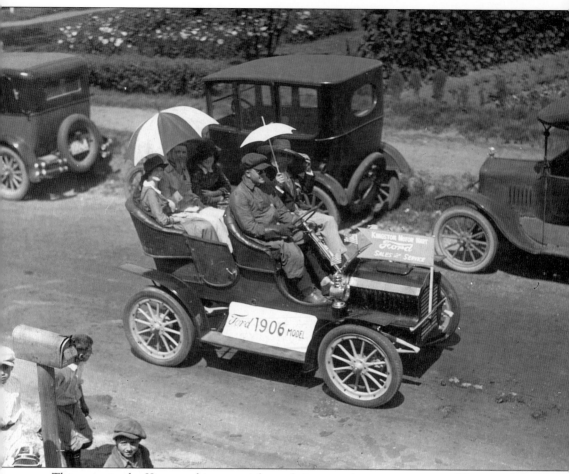

This entry in the Kingston bicentennial parade is an antique car, courtesy of Kingston Motor Mart. The 1906 Ford was only 20 years old. The driver is identified as Joseph Lamborghini.

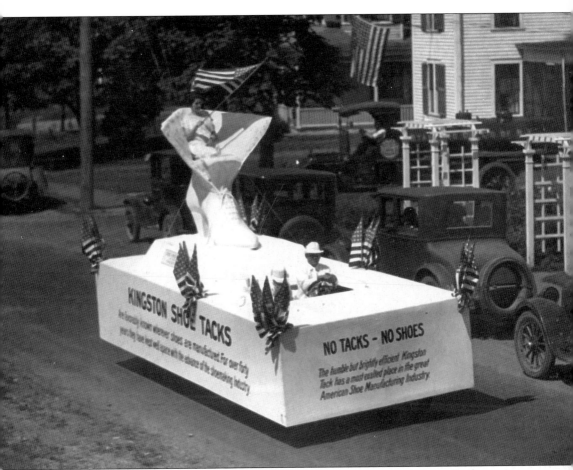

In this 200th anniversary parade entry, the float of Kingston Shoe Tacks proudly states that "the humble but brightly efficient Kingston Tack has a most exalted place in the great American Shoe Manufacturing Industry."

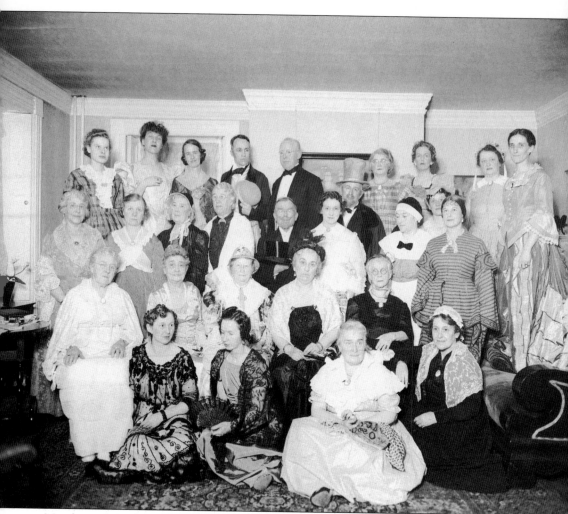

Members of the Jones River Village Club of Kingston observed the 30th anniversary of the organization with a costume part at the annual meeting held at the home of Mr. and Mrs. Harold J. Weston. Emily Drew, Kingston historian and photographer, is standing in the third row, eighth from the left. Another notable Kingston historian, Helen Foster, is pictured in the back row, third from the left. The extraordinary Helen Foster, a lifelong resident of Kingston, died in 1998 at the age of 97. Her accomplishments and efforts on behalf of Kingston are so legendary that a Helen Foster Day was proclaimed on her 95th birthday. She chronicled daily life in Kingston, kept voluminous diaries about life in Kingston in the 20th century, and created a series, "Then and Now," for the *Kingston Reporter*.

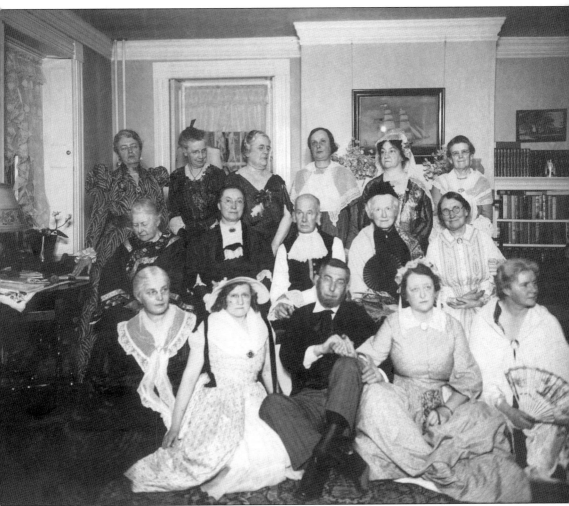

At another meeting of the Jones River Village Club (*c.* 1940s), those in attendance are, from left to right, as follows: (front row) Sally Dawes Chase, Florence McDonald, Harold Weston, Lucy Weston, and Katherine Alden; (middle row) Annie Fuller, Dennie Taylor, Maj. George Sever, Bertha Koshman, and Mary Drew; (back row) Ethel Turner, Martha Clarke, ? Rogers, Helen Adams, Margaret Wilson Lee, and Louisa Holmes.

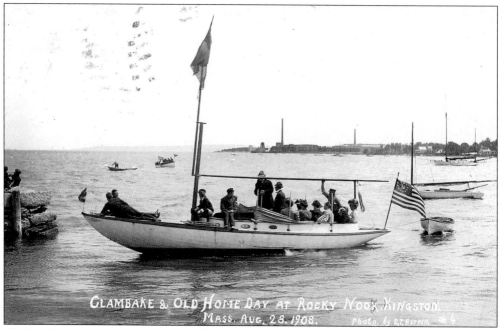

The Rocky Nook area and Delano's Wharf were popular sites for boating activities, so much so that a postcard series was made especially commemorating one such event held there. In this view, a clambake and Old Home Day are being celebrated off what is now Gray's Beach on August 28, 1908. The wharf is at the left and Plymouth Cordage is in the background.

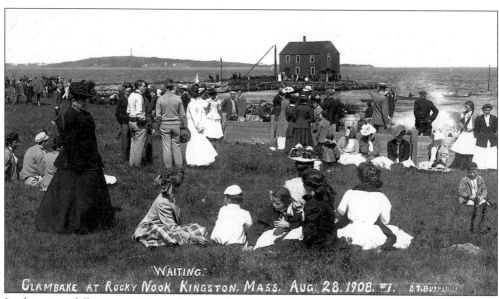

In this view, folks are waiting at the same festive occasion.

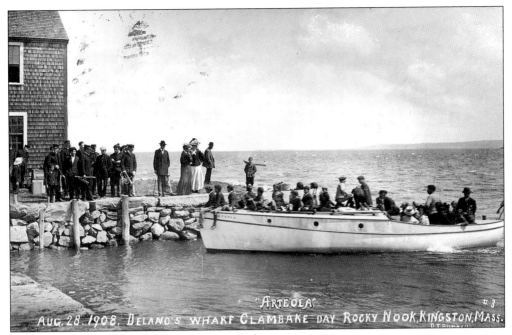

Pictured here is the *Arteola* either arriving or departing.

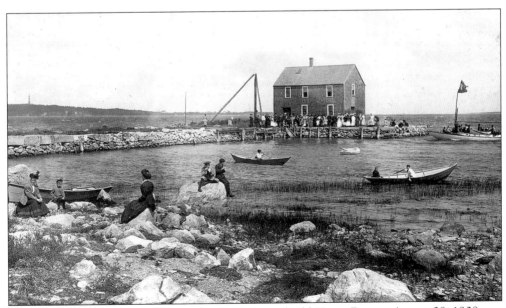

The wharf is crowded with folks at the clambake and Old Home Day on August 28, 1908.

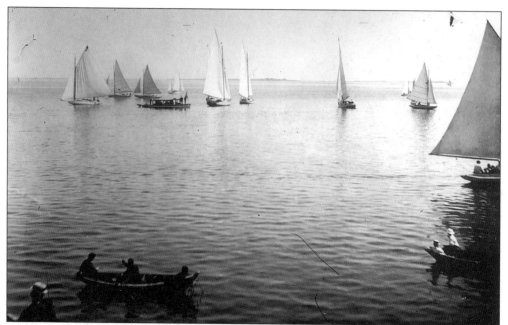

Pictured here is the Kingston Yacht Club race in 1901. According to Emily Drew, the last week in August became Regatta Week for the local Kingston Bay.

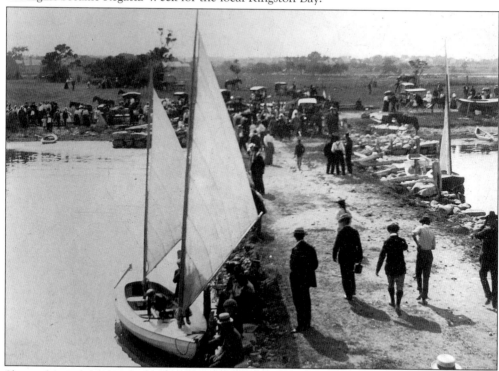

Shown here is the Kingston Regatta at Delano's Wharf in 1899. E. Drew also says that for Regatta Week in Kingston, the Kingston Yacht Club concentrated on one big day at Rocky Nook Wharf. A day of racing, a clambake, and water sports at the wharf was followed by a ball in the evening at the town hall.

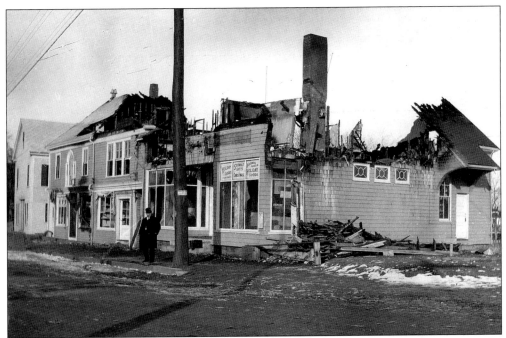

In December 1911, a fire destroyed the Adams Block in downtown Kingston except for the north end. The damaged section was rebuilt and continues as a commercial block today, although not as it appears here.

Fire damage is being viewed on Prospect Hill after the "Great Fire" of July 1908. According to Melville, no cause was found for the devastating fire in the southern part of town.

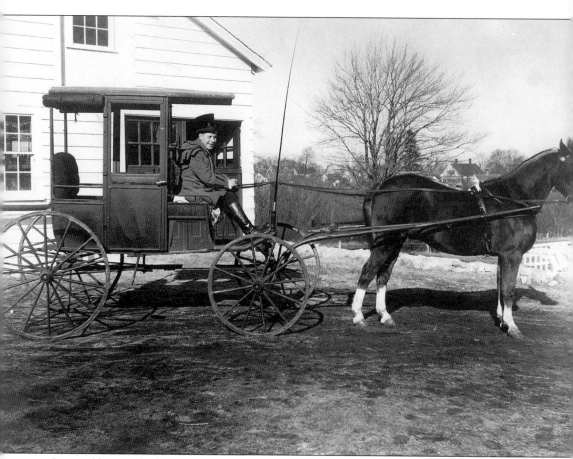

Pictured here is the horse and coach filmed in the Kingston High School production of *Uncut Diamond*, *c*. 1940–1941. The coachman is identified as John Watson and the horse, who belonged to Russell Loring, as Chief.

Six

KINGSTON IN WARTIME

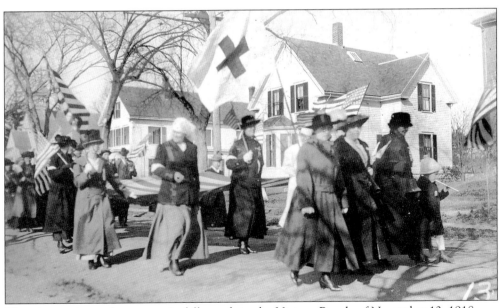

This picture shows the women in full march in the Victory Parade of November 12, 1918.

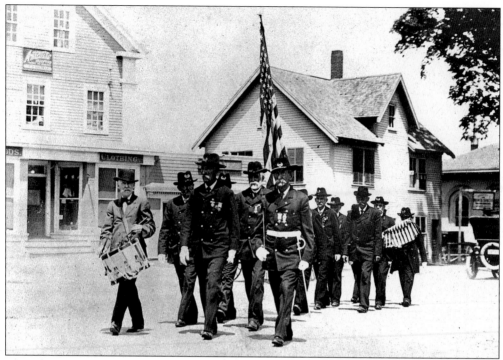

Here the honorable members of the Grand Army of the Republic march through Kingston center *c.* 1908. A version of the original L. Keith store is at the left of the photograph.

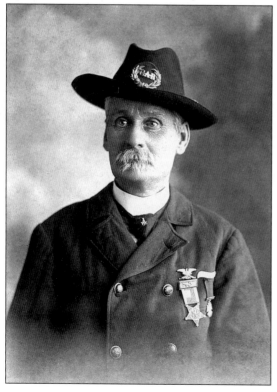

Capt. George Bonney was proud to be photographed in the uniform of the Grand Army of the Republic.

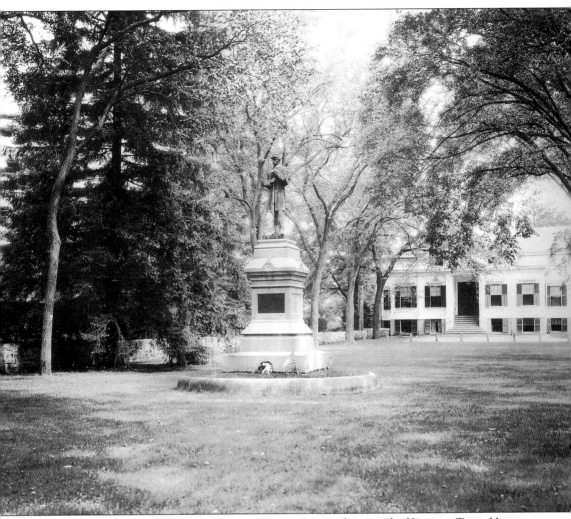

This photograph depicts the core of the town's civic center, showing the Kingston Town House and the Civil War Monument situated on the town green, with the Old Burying Ground adjacent to the left. At the center is the monument, which was constructed in 1883. The monument comprises a six-foot-tall, cast-bronze statue of a Union soldier. The south elevation of the monument bears a plaque that reads, "Commemorative of the patriotic citizens of Kingston who in the War of the Rebellion, 1861–1865, voluntarily imperiled their lives for liberty and union. Erected October A.D. 1883. A gift of the town." The monument's north elevation bears a bronze plaque with a list of names of those who died in service.

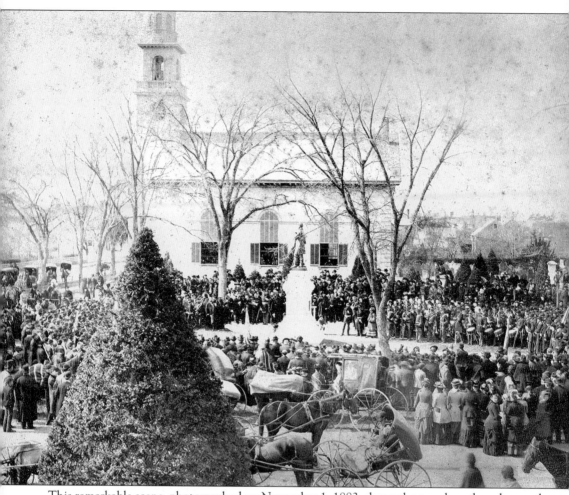

This remarkable scene, photographed on November 1, 1883, shows the people gathered around for the dedication of the memorial on the town green "to the patriotic citizens of Kingston who fought in the War of the Rebellion (1861–1865)." Kingston was active in the Civil War, sending 154 men off to fight, some 10 percent of the population of the town of 1,655 in 1860. On June 23, 1883, permission was granted to the Martha Sever Post No. 154 of the Grand Army of the Republic to erect a soldier's monument on the town green. The monument commemorates 154 men who served, 16 of whom were either killed in action or died in service. The First Parish Church and the Old Burying Ground are in the background.

Here veterans of the Civil War and their sons are photographed in front of the Adams Block in Kingston center. Capt. George Bonney is pictured sixth from the left. The Martha Sever Post No. 154 of the Grand Army of the Republic had its headquarters on the second floor of this building.

Martha Sever was the great-granddaughter of Squire William Sever and served as a nurse in the Civil War. Martha Sever lost her life while in service, as did 16 men. Her name is listed on the Civil War monument on the town green. The Kingston Grand Army of the Republic post was named the Martha Sever Post for the nurse.

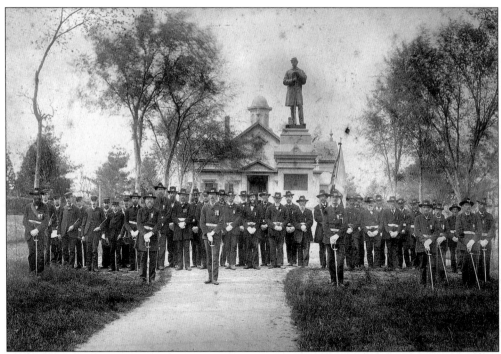

This unique photograph is undated but shows members of the Grand Army of the Republic on the town green in front of the soldier's monument with the Kingston Town House in the background.

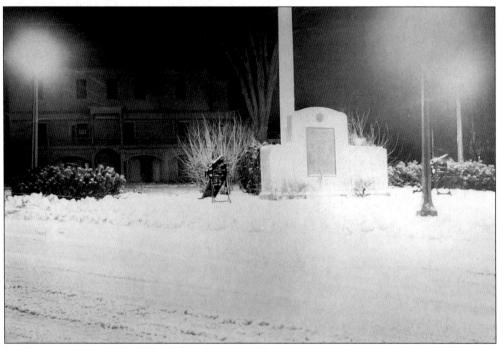

In this snowy scene, the World War I memorial at the intersection of Green and Summer Streets is shown with the Kingston Inn in the background.

The Kingston Playground, behind the Reed Community Building, is the setting for this gathering of the Veterans of the Second World War.

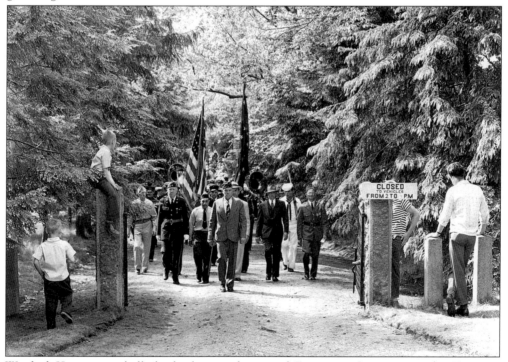

Winfred Keene, marshall, leads the parade out of Evergreen Cemetery at the Kingston Memorial Day exercises in 1946.

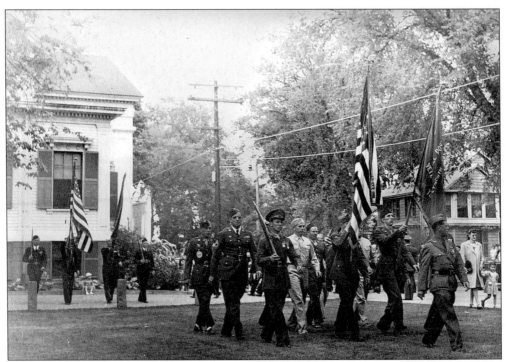

In this Memorial Day formation in front of the Kingston Town House are the Plymouth Post Veterans and Kingston American Legion Post 108 Color Bearers.

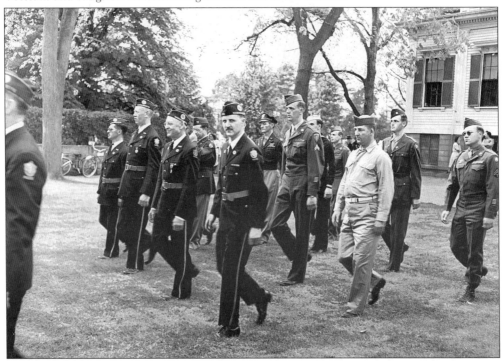

Shown here is the Kingston American Legion Post 108 on the town green on Memorial Day in 1946.

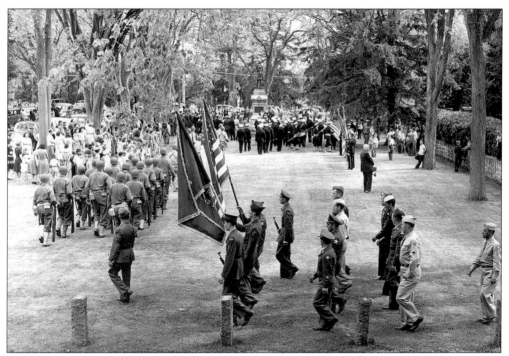

The parade on the town green, looking from the Kingston Town House toward the Soldier's Monument highlights the Kingston Memorial Day exercises in 1946.

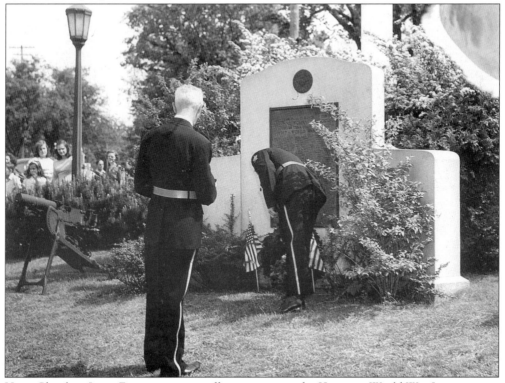

Here, Chaplain Leon Fontaine is seen offering prayer at the Kingston World War I monument.

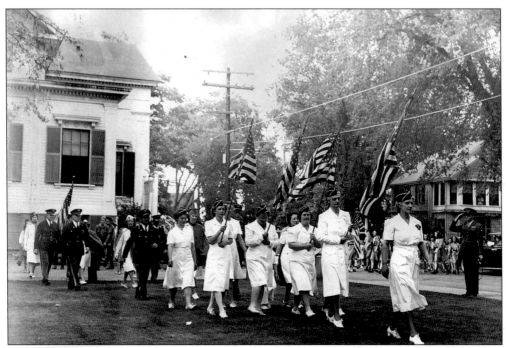

Here in formation is the Kingston American Legion Post 108 Auxiliary on Memorial Day 1946 in Kingston.

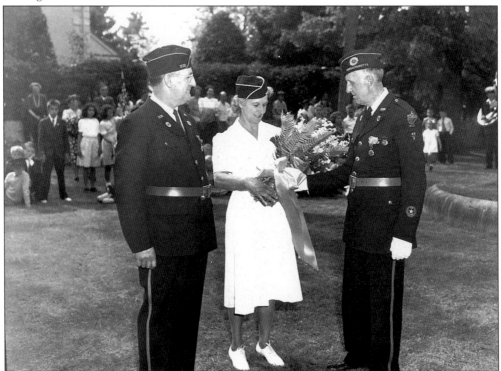

Pictured here is Roger Bates P.C. presenting a bouquet to Kingston Post president Lillian Anderson. Alton P. Chandler is on the left.

Seven

BUSINESS AND COMMERCE

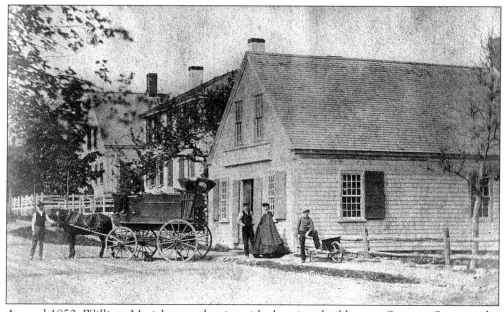

Around 1850, William Myrick started a tinsmith shop in a building on Summer Street at the corner of Maple Street. He remained there until success led him to his new building, the Myrick Block, in 1878 at Summer and Evergreen Streets.

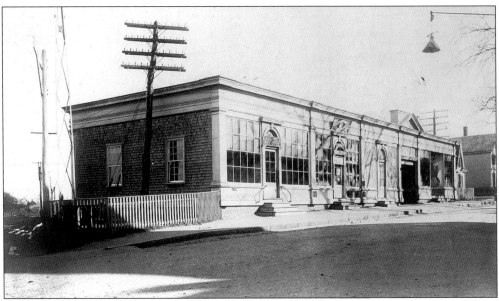

The Adams Block, also referred to as the post office building in its time, is not that same Adams Block that is located a short distance away in the center of town. This block was built in 1906 as a commercial building. The Old Colony Railroad was established just north of this location in 1845. With the arrival of the railroad, commercial development grew around this area. Early tenants were the post office, a hardware store, and grocery store. The post office later moved to another location.

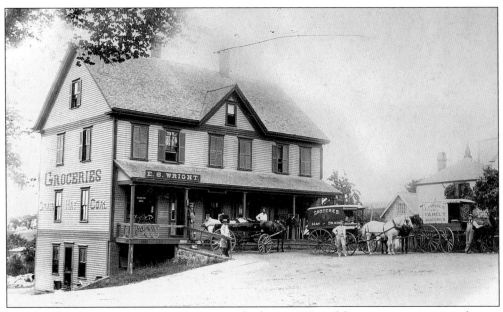

This building at 41–43 Summer Street was built in 1875 and began as a grocery and meat store run by E.S. Wright. It later became Farrington's Market. The proximity of the railroad tracks allowed for an offshoot of track directly to the back of the establishment to make deliveries simpler.

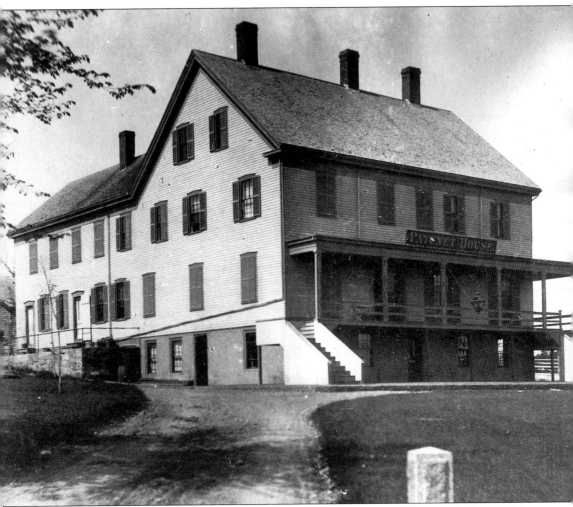

The Kingston Inn, as it is generally known, was called Patuxet House when it was built in 1854 at the junction of Summer and Green Streets. Josiah Cushman bought the land from Spencer Cushman and then borrowed $1,500 from Spencer to build the establishment. The Old Colony Railroad began operations nine years earlier and would prove to be a great asset for the hotel business. Cushman ran Patuxet House for about 25 years. Henry K. Keith took over the operation shortly after 1880. The inn operated under several names over the years.

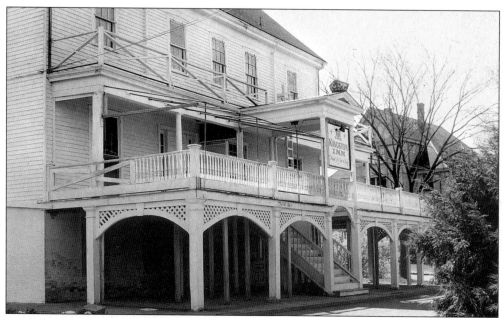

The inn was Hotel Kingston around the turn of the century. It was later the scene of what Boston newspapers called the "Kingston Inn's rum-runner's murder." In 1927, it was called Bay View Inn. The building was empty for years before Coley and Lillie Mae Hayes of New York reopened the Kingston Inn in the 1950s as a summer resort catering to black families. It was purchased and razed by the New England Telephone Company in 1970. The Kingston Public Library, having vacated the Adams Library building, is now located on the site in the former telephone company building.

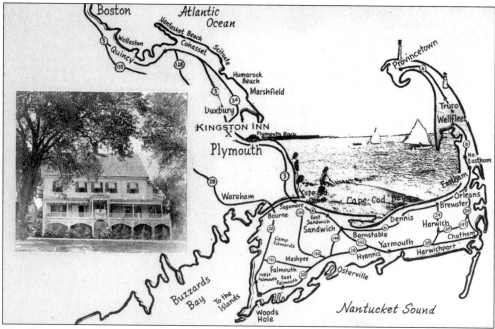

The Kingston Inn, in its prime, had an extensive advertising and promotion program. The postcard shown here is an example.

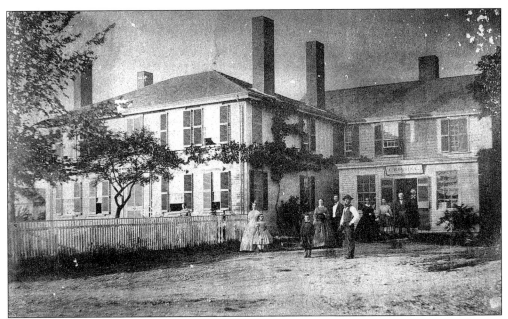

This image shows the C. Robbins store on Main Street in the Rocky Nook section of town. Melville states that the land in this area of Kingston was granted to William Shurtleff and was then held by Jacob Cooke when he married the widow Shurtleff. Cooke's heirs sold the land to Joshua Delano in 1749, establishing the Delano family of Duxbury in Kingston. The C. Robbins store was located at No. 87 of the Delano built houses in this area of Main Street. The 1876 map lists Charles Robbins and Eben Sherman as occupants and Charles Robbins as the owner.

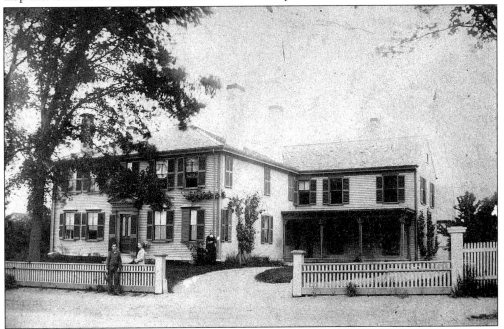

Pictured here is the same house, the store area somewhat altered. It is identified on the photograph as "Grandpa Robbins House at Rocky Nook, Kingston." By 1903, Mrs. Ebenezer Sherman owned the building and she is pictured here with her two children.

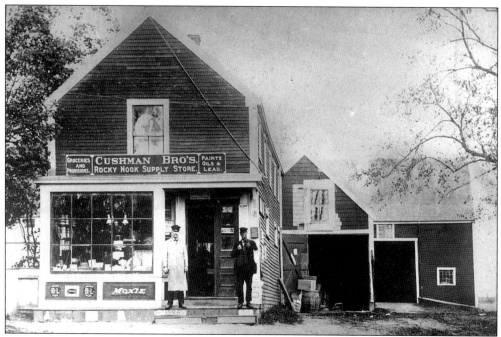

Before George W. and Fred C. Cushman ran this store, is was owned by Philander Cobb who, in 1845, bought the structure in Plymouth and moved it to Rocky Nook, where he reconstructed it. It was known as P. Cobb's store.

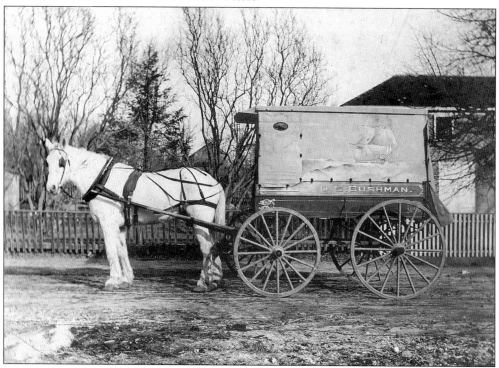

The Cushman Brothers provided a fine delivery service. The horse was known as John White, and this handsome wagon was painted with a sailing vessel.

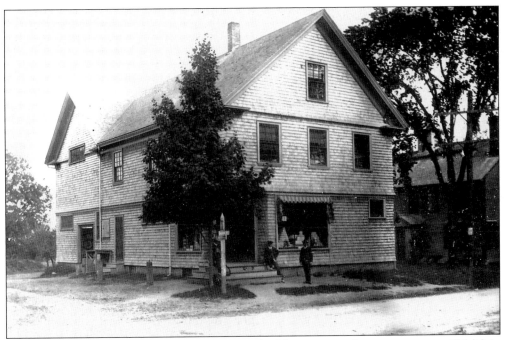

George Cushman, who lived on Green Street, had kept a store for many years at 196 Main Street in the wing of the former David Beal house. Before 1903, he built a new store building, pictured here and still extant on an empty lot at the corner of Main and Linden Streets.

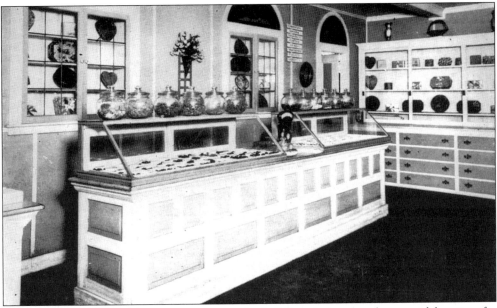

After Cushman stopped keeping a store in the building, it became the second location for Ye Kynge's Town Sweetes, pictured here, which was originally located at 215 Main Street. When the confectioners left the building, it was left vacant for a time and then converted into apartments.

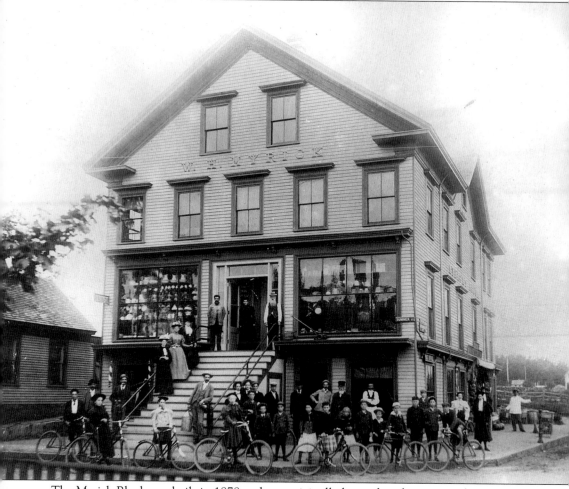

The Myrick Block was built in 1878 and was originally located at the corner of Evergreen and Summer Streets. It was moved to its present site *c.* 1940 to make room for the gas station that now occupies the corner. In 1878, the building contained the post office, a fruit store, and a hardware store. By the early 20th century, the fruit store had moved to the first floor and a general store was on the second; the post office had moved across the street. Until the time it was moved, it housed a number of commercial establishments. The building, although it has been moved, is considered one of the best-preserved 19th-century commercial buildings in Kingston.

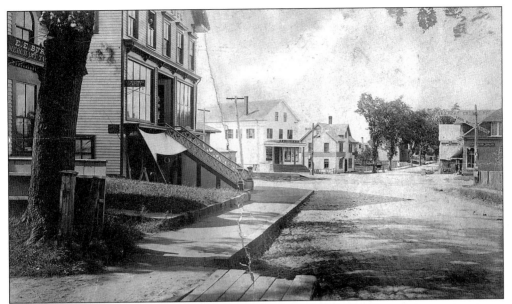

This early view of the center of Kingston shows a portion of the facade and the entry stairway of the Myrick Block at the left. In this photograph, the original railroad station still sits next to the building and has not yet been moved down the street.

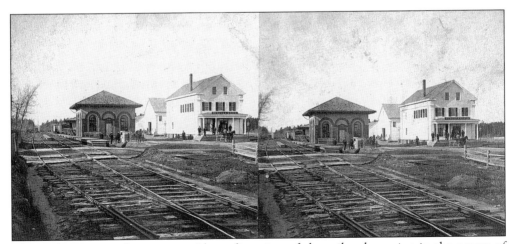

This early stereograph image provides a fine view of the railroad crossing in the center of Kingston. The Burges and Keith store sits to the right of the railroad station.

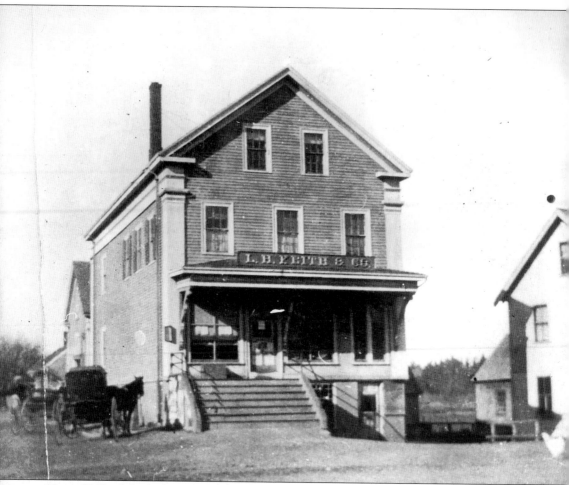

Henry K. Keith built this store at 58–60 Summer Street. It opened in September 1848 on land purchased from George and Frederic Adams and was considered the largest general store in the country, with dry goods, groceries, grain and coal, a millinery, and a tailoring shop.

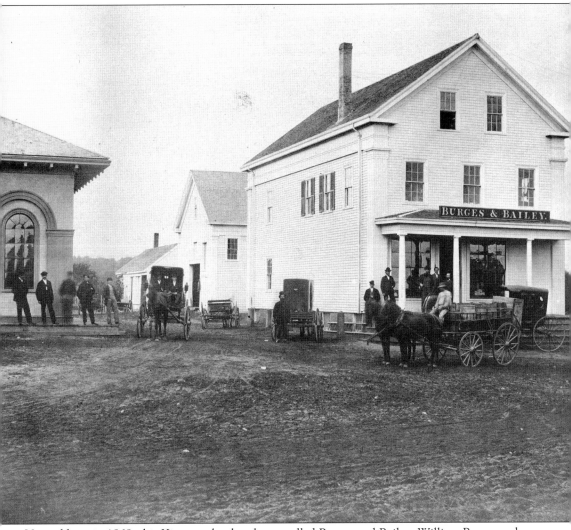

Viewed here in 1868, this Kingston landmark was called Burges and Bailey. William Burges and Nahum Bailey had been employees of Keith and had purchased the store in 1865. As Doris Johnson Melville explains, following Burges and Bailey, the store was known as Burges and Keith, W.H. Burges and Company, Lewis H. Keith, Whitman and Sparrow, F.N. Whitman and Company, and Toabe's Kingston Hardware.

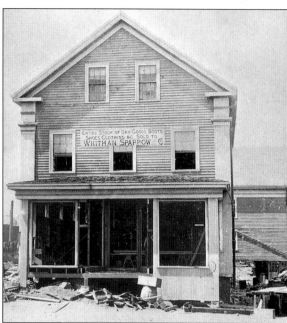

The store was remodeled in the early 1900s and occupied by Toabe's Kingston Hardware after 1917.

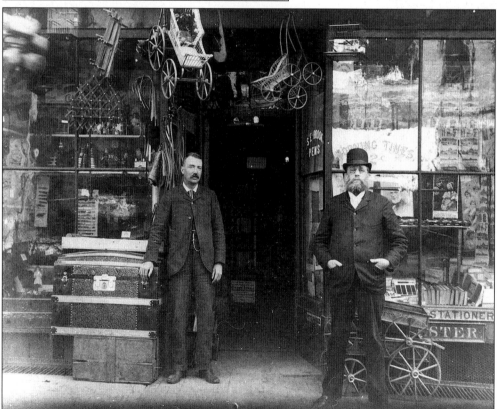

Which of the many owners of the original Keith store is the actual proprietor at the time of this picture is unknown. However, the variety of products available shown would certainly attest to a well-stocked general store.

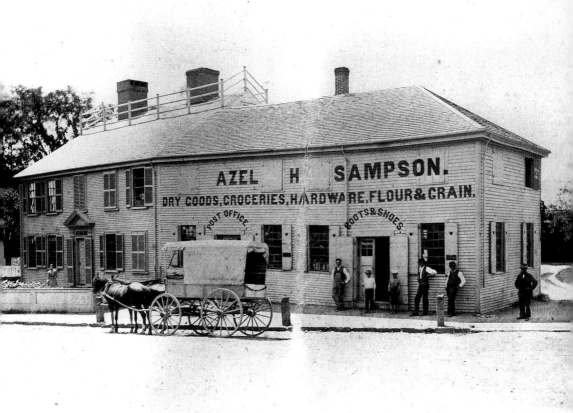

The David Beal house, at 196 Main Street, at the Point, is again shown with the store wing, which was added in 1794. According to Melville, the store was later operated by David Beal Jr. and then by his son-in-law Horace L. Collamore. Subsequently, Henry Hunt and his son-in-law Azel Sampson purchased the store.

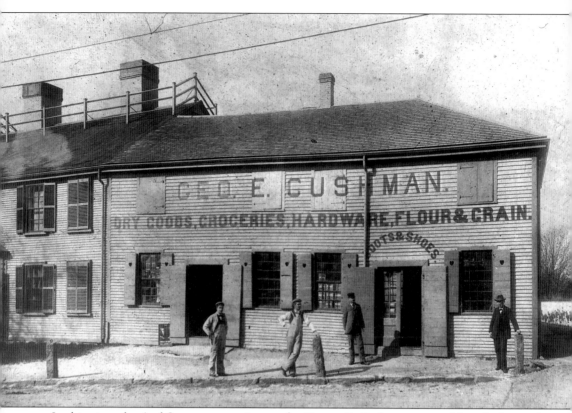

In this view, the Azel Sampson store is now the George E. Cushman store, although the goods available seem to be the same. Melville writes that George E. Cushman started as a young assistant to Sampson, eventually became the owner, and operated the store until the wing was torn down in 1902. The original David Beal house, without its store wing, is recognizable at the Point.

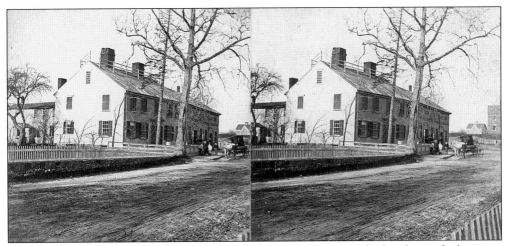

This fine stereoview shows the David Beal house with the store attached and open for business. The view on the right clearly shows the Point and Rev. Joseph Stacy's house.

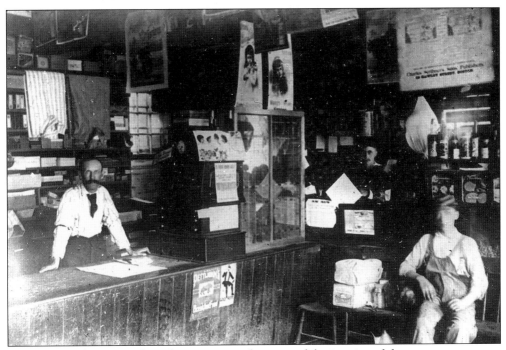

George E. Cushman stands at the counter in this view of the interior of the store.

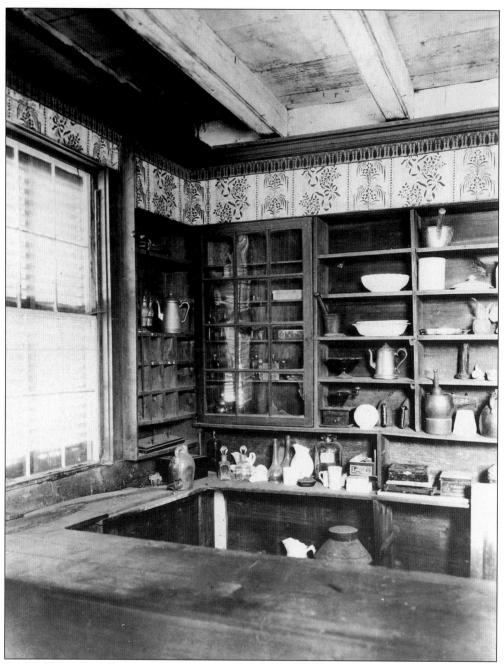

Pictured here is a different store, on a corner of the Joseph Holmes house at the corner of Main and Elm Streets. The store was used continuously until after the death of Holmes in 1863. When he died, the store was closed as it was. It remained that way for a long time.

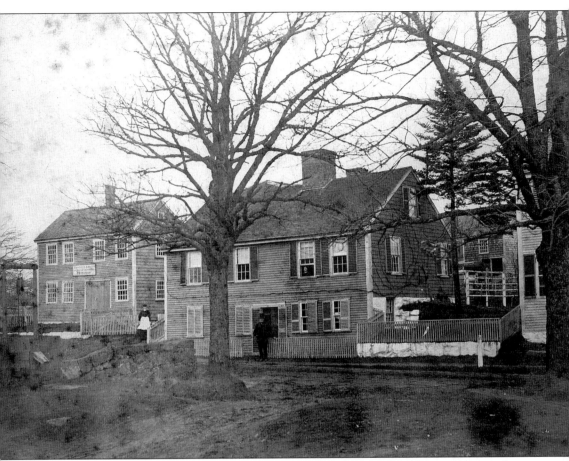

The Seth Chipman Cooperage appears on the left in this photograph and was constructed in the mid-18th century. The building served as the cooper shop of Seth and his son Seth Jr. until it was sold to the Stetson family next door on Summer Street for use as a harness-and-luggage-making shop. That was its use at the time of this photograph, evident in a magnified view of the sign on the front of the building. These dwellings sit opposite the Point and are seen here before the widening of the road.

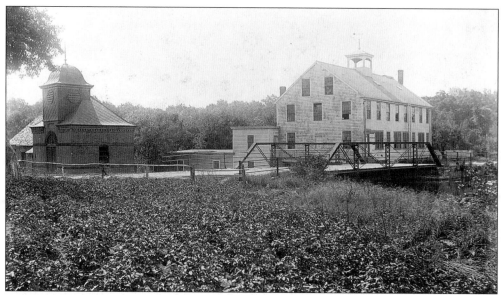

For understandable reasons, visual record of Kingston's early industrial history is almost nonexistent. Emily Drew writes, "on Jones River and its tributaries, within the limits of Kingston township, there have to my knowledge twenty-four water privileges from which more than eighty separate industries have taken power. By 1926, there were only five of the original water privileges in use. One of these was the Pumping Station of the town's water system at the lower privilege on the Jones River, shown at the left, *c.* 1894." In 1886, the Town of Kingston purchased the building and waterpower from the Kingston Aqueduct Company. On the south bank of the river, the building at the time of this photograph was occupied by the Hurd's Tack Factory.

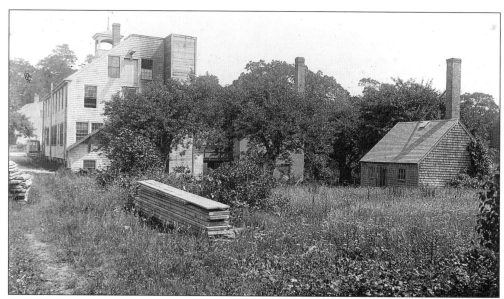

Seen here is another view of the building which, in this photograph, is identified as a thread factory that occupied the space before the tack factory.

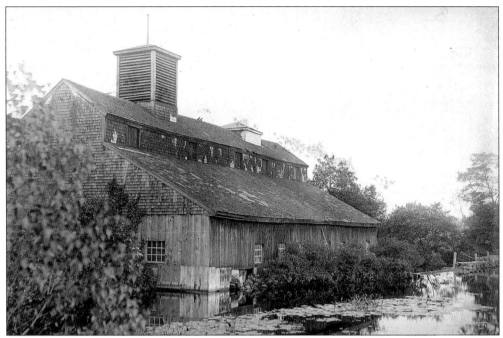

The Triphammer Privilege, where Wapping Road crosses the Jones River has a long history, started as a sawmill but is best known as Anchor Forge. The development of the iron industry was the chief gain during the first 50 years of the town's existence. In the early 19th century, many anchors were forged at this privilege.

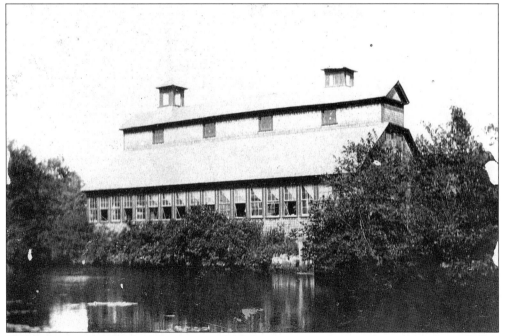

Shown here is the Anchor Forge site, which was a cotton factory for many years and then became a tack factory started by Henry M. Jones. Mayflower Worsted Company purchased the building in 1919.

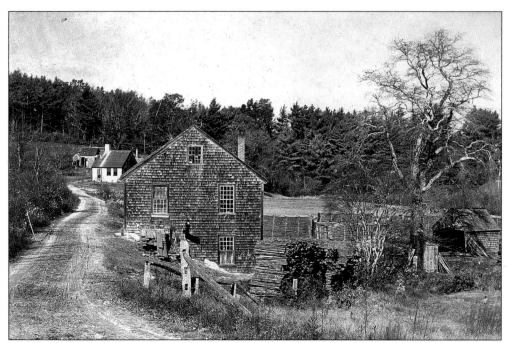

Trout Brook on upper Elm Street had five privileges. According to E. Drew, in 1794, the first anchor works in town were founded on Trout Brook. Pictured here is the site of Sylvanus Bryant's Mill, originally an anchor forge. It operated as Sylvanus Bryant's saw and box-board mill *c.* 1870 and was abandoned *c.* 1900.

Tack factories had become numerous, and practically every water privilege had furnished power for a tack or rivet works, besides the Maglathlin Tack Factory (shown), which was established after steam became popular and waterpower was no longer necessary.

Eight

TRANSPORTATION AND SHIPBUILDING

Getting around was simpler in earlier days, as shown in this undated photograph of a man and his dog making their way down Thomas Hill toward the Jones River.

In this view, Mrs. Frank Holmes (front seat) and Abby B. Jones have paid a visit to the home of Olive Delano at Rocky Nook.

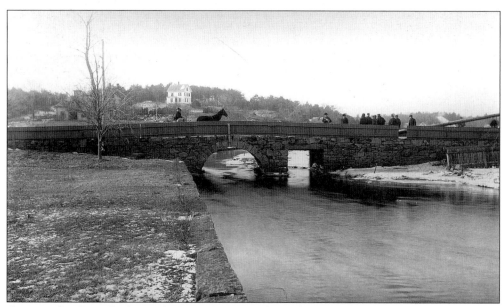

Crossing the Great Bridge at the Jones River, as shown here, was by carriage or on foot.

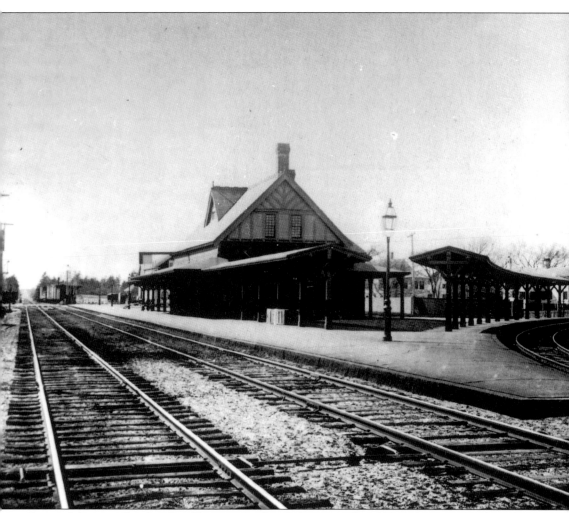

Pictured here is the familiar Kingston Railroad Station. The Old Colony Railroad, with Kingston resident James Sever as president, built the original tracks between Boston and Plymouth in 1845. The Old Colony properties were leased in 1893 to the New Haven Railroad, which operated train service until 1959. With the revival of the commuter rail in 1997, the old track bed was rebuilt for service from Boston to Kingston, but trains no longer stopped at the original depot. The main depot remains today, without roofing over platforms and tracks to the right. It was restored a few years back and is currently used commercially.

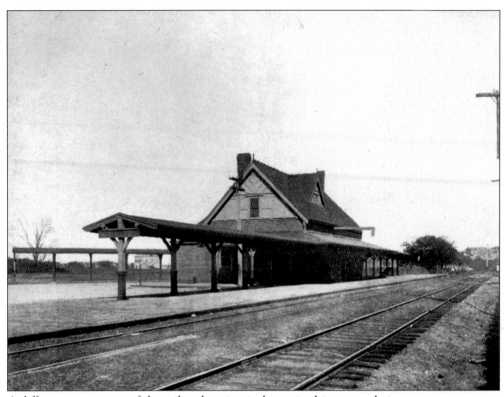

A different perspective of the railroad station is shown in this postcard view.

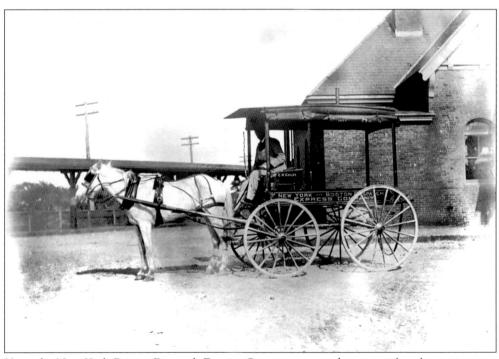

Here, the New York-Boston Dispatch Express Company wagon has stopped at the station.

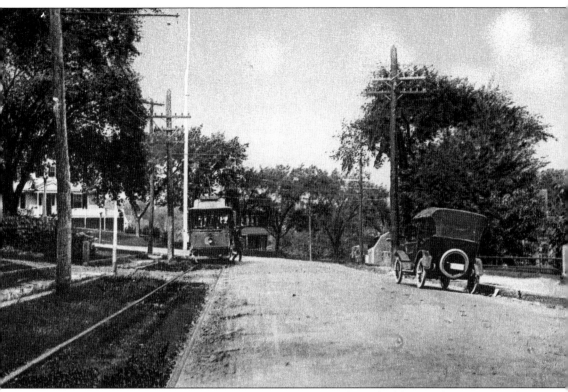

The Kingston trolley is seen stopping opposite the Adams Library building at the junction of Main and Green Streets. The trolley line originally came to Kingston from Plymouth in 1889, as far as Cobb's Store at Rocky Nook for the convenience of Plymouth Cordage workers. In 1894, it was extended west from Cobb's Store through the center of Kingston, along Main Street and then Summer Street, turning left opposite the library at the Green Street intersection and right again on Main Street to a carbarn on Pembroke Street.

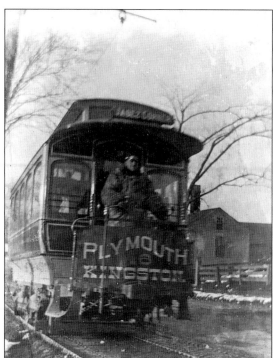

The Plymouth and Kingston Street Railway was a predecessor of the Plymouth & Brockton Street Railway, and its route took it from near Howland's Lane in Kingston to Jabez Corner in Plymouth, a distance of nearly four miles.

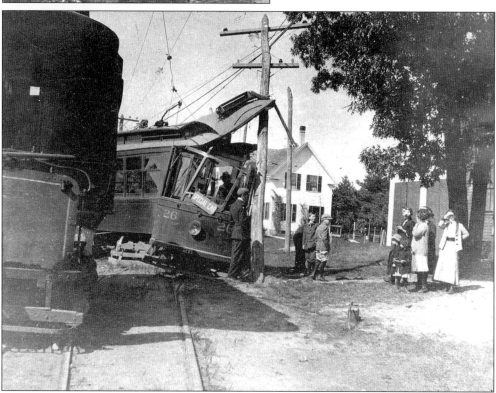

The line did not always run smoothly as can be seen by this accident at Evergreen Street near the carbarn on Pembroke Street.

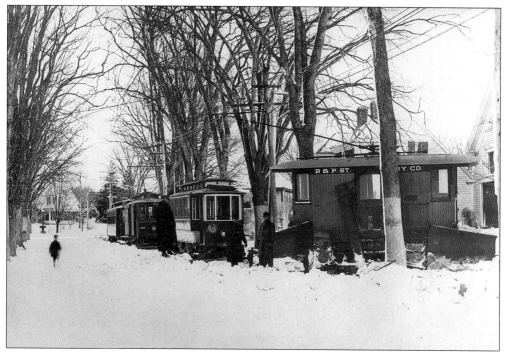

The trolleys were well equipped to deal with snow emergencies.

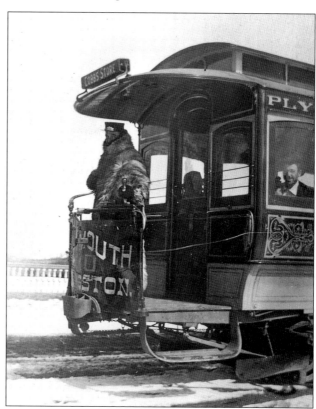

Conductors were equally well prepared to deal with the cold temperatures at their post in front.

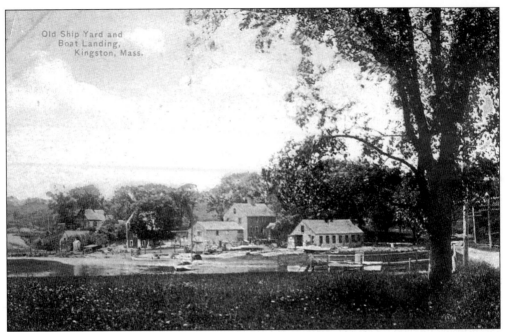

This postcard view shows the Jones River Shipyard, which has a long history in Kingston. It is a well-known fact that shipbuilding was the largest and most profitable business the town ever had. There were some 276 vessels with a total of some 34,000 tons built in the Jones River shipyards between 1726 and 1887. The landing originally belonged to Maj. John Bradford's farm and was eventually sold off by the family to different families involved in the shipbuilding trades.

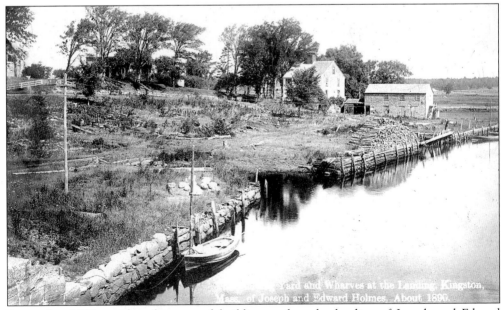

Pictured c. 1890 are the wharves and building yard at the landing of Joseph and Edward Holmes. It has been recorded that Joseph Homes built 82 vessels at his yards at the landing. From 1830 to 1855, he was the largest individual ship owner in the United States.

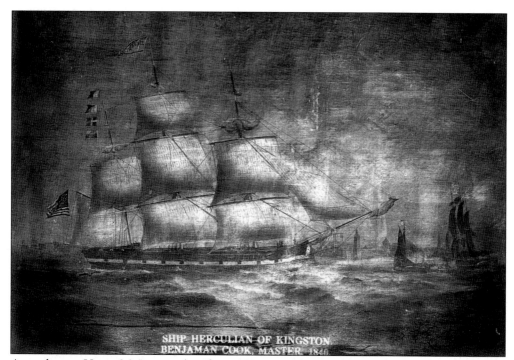

SHIP HERCULIAN OF KINGSTON.
BENJAMAN COOK, MASTER. 1840

According to Henry M. Jones in his *Ships of Kingston,* the ship *Herculean* was built at Kingston by Joseph Holmes and was the largest and most expensive vessel that had been built in Kingston at this time. She was built in 1839, and her first voyage was from Boston to Mobile, Alabama, in October of that year.

According to E. Drew, Joseph Holmes planned to call his ship *Hercules* but learned that there was already one of that name in the registry. The ship's figurehead is shown here and was called "Hercules." It apparently weighed 800 pounds and eventually proved too great a weight to hang from the ship's bow. Before long, the ship developed serious problems attributed to the figurehead's weight. It was removed and brought back to the Holmes yard at Kingston.

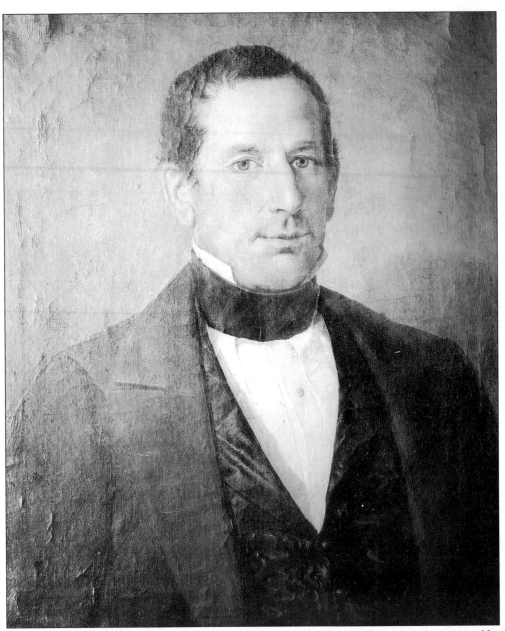

This image of Capt. Benjamin Cook, master of the ship *Herculean*, is from a portrait painted by Giuseppe Mazzarese P. Trapani and is located in the Kingston Public Library. Cook always lived in Kingston and owned a house known as Spring Brook Farm (still extant), located on Wapping Road. However, information about the voyages he made in Kingston vessels is scant. He made numerous trips on ships made in the Kingston yards and, as early as 1830, was on board the *Helen Mar*, as a mate. Following his command of the *Herculean* from 1839 to 1843, he was in command of another Kingston vessel, the *Alesto*, owned by John Sever and Joshua Delano of Kingston. It is believed because he was often at sea and did visit foreign ports, including Italian ports, that the artist of this portrait was a port painter.

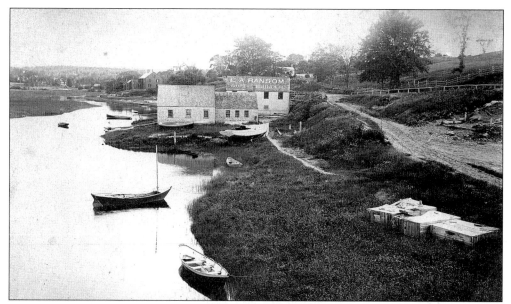

Jones writes that, after giving up the sea, Edward A. Ransom carried on a lobster fishing business, and it was then that his attention was called to make improvements to the design of boats used for lobstering in the bay. He began boatbuilding on the Jones River in 1879 and was known for his improvements to lobster boats and yachts.

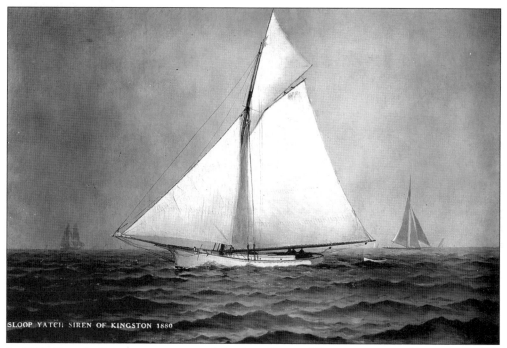

SLOOP YATCH SIREN OF KINGSTON 1880

In 1883, Captain Ransom was master of the sloop *Siren*, of Kingston, pictured here. According to Jones, she was owned by Lewis H. Keith in 1877 and used by him for racing and cruising until she was sold in 1884. While owned by Keith, she was the fastest sloop of her size on the New England coast.

125

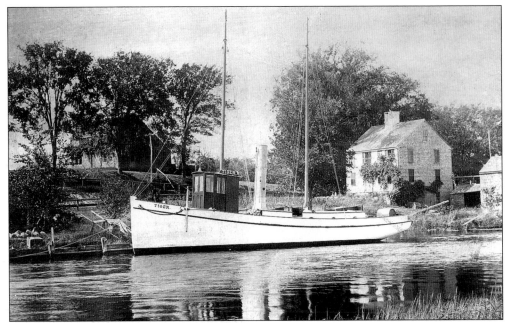

Edward A. Ransom built *Tiger*, a 30-ton steamer, at Kingston in 1898. This was the only steamer ever built on the Jones River, and the largest vessel built on the river since 1874. Captain Ransom, her master, used her for a few years for offshore lobstering and fishing. In this image of the *Tiger*, the Maj. John Bradford House is to the left on the hill.

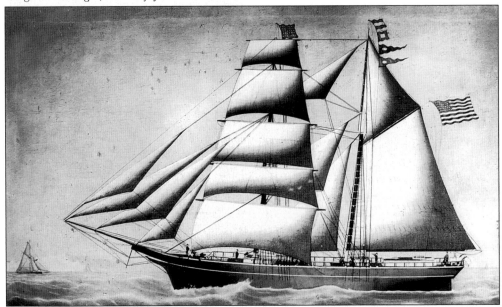

As described in *Ships of Kingston*, the Brig *Helen Holmes*, pictured here, was the last vessel built by Edward Holmes (son of Joseph Holmes) in the shipyard at the landing just below the railroad bridge. She was launched in the spring of 1874 and was named for the wife of Edward Holmes. After voyages to the Mediterranean, New Zealand, and Scotland, she returned to Boston. She was next chartered for a voyage to South America and, on the return, went ashore at Martha's Vineyard, and was lost, cargo and all, in bad weather.